Desire Paths

Real Walks to Nonreal Places

Roy Bayfield

Published in this first edition in 2016 by:

Triarchy Press

Axminster, England

+44 (0)1297 631456

info@triarchypress.net

www.triarchypress.net

Cover Photo:
'Desire Path' by Mark Jensen (marksdk)
www.flickr.com/photos/markcph/3433296212/
Licensed under CC BY-SA 2.0. Cropped from original.

A catalogue record for this book is available from the British Library.

Paperback ISBN: 978-1-911193-04-3
ePub ISBN: 978-1-911193-05-0

...only the one who travels every road will not find the limits of the soul.

<div align="right">– Heraclitus (Betegh, 2009)</div>

I believe that I know everything worth knowing about roads: soft roads, hard roads, wide roads, narrow roads, stony, muddy, cemented, boggy, snowy, hilly, gravelled, slippery, dusty. My feet have taught me everything worth knowing about roads...

<div align="right">– *Legion of the Damned* (Hassel, [1957] 2007)</div>

I Am the Walker

<div align="right">– The Creation, title of studio out-take recorded c.1967</div>

Contents

Intro: Mythogeography

On Thursday 11th November, 2010 I discovered that I was existing inside a book.

I was on a train at the time, travelling through Shropshire towards Cardiff, heading for an art exhibition titled 'Everybody Knows This Is Nowhere', dividing my time between looking at the hills and reading. The book was called *Mythogeography*. It had no apparent author, apart from some implausibly-named individuals and organisations. It was a book about walking.

In those days, I walked ardently. For nearly three years I had been making a long, piece-by-piece journey through England, a DIY pilgrimage from where I lived in North West England back to my home-town on the South coast – attempting to experience the territory of my half-century of existence as directly as possible. A journey I had made many times at speed in trains and cars, now being done a step at a time, with side-trips and digressions. Mostly, I had avoided places of beauty and tourist highlights: my route tended to meander through the outskirts of towns, on footpaths that had been absorbed into suburbs and alongside railways and motorways, with rest-stops in corporate motels and refreshment breaks in chain pubs. Unnamed instinct had led me away from landscapes such as the hills that surrounded my train journey – for some reason, wilder more 'natural' places and officially-designated beauty spots held little interest. Instead I found a certain exhilaration in hiking through the margins.

Between walks I wrote a blog that consisted partly of travelogue and partly of poeticised musings. And I read widely on the topic of walking, finding provocative inspiration in various texts under the ambiguous banner of 'psychogeography'. As someone trying to hack into the reality of the terrain I was walking through, the "study of the specific effects of the geographical environment … on the emotions and behavior of individuals" (as Guy Debord [1955] of the Situationist International described the practice) had a definite appeal. The idea that I could be like "the wanderer, the stroller, the flâneur and the stalker" described in Merlin Coverley's book *Psychogeography* was attractive, joining a lineage whose experiences ranged "from the nocturnal expeditions of de Quincey to the surrealist wanderings

of Breton and Aragon, from the Situationist *dérive* to the heroic treks of Iain Sinclair" (Coverley, 2010). I had a sense that these perspectives would help my dimly-apprehended quest to experience the true nature of the places I walked within. However, I also had a niggling awareness that adopting tactics devised by others was basically just following instructions. 'Doing some psychogeography' could just be a leisure activity, an intellectualised version of spotting items in an *I-Spy* guide book – 'Surveillance Camera: 2 points'; 'Occult Graffiti: 5 points'... not that there was anything wrong with that, but I wanted adventure rather than formula.

I had bought the newly-published *Mythogeography* book as part of my ongoing search for interesting input. I liked the title, hoping that *mytho*geography would prove to be a fresher version of *psycho*geography, like Tarzan being more exciting than Mowgli: the basic idea taken and given more energy, the narrative opened up and multiplied. Seeing the book mentioned online I had ordered it through the post, then brought it along on my trip to Wales for something to read. It was a slightly oversized paperback, the cover matt-laminate-serious, the silky white pages filled with symbols, codes, photographs and illustrations. It looked like several books combined into one – an academic tract, work of fiction, art-prank, guidebook, scrapbook, notebook waiting for more things to be written in it. The covers and early pages made many wild statements of intent:

A Guide to Walking Sideways

Compiled from the diaries, manifestos, notes, prospectuses, records and everyday utopias of the Pedestrian Resistance

Theoretical and practical sections compiled, edited and annotated by The Central Committees from the documents of the radical and philosophical walking movements (confessions, memoirs, pamphlets, ghosts, various)

Deceitful and hopeful, this is the first manifesto of a new kind of everyday.

Walking 4.0

After I changed trains at Chester I started to read in earnest, knowing that I had a couple of hours of undisturbed time. I was pleased to find that the book wasn't just a retread of well-worn 'psychogeography' concepts. Having said that I didn't quite know what I *was* reading – the pages contained a bizarre admixture of text and images, a palimpsest of concepts and allusions

unfolding with no comfortable structure or solid ground ('everybody knows this is nowhere').

On page 113 I was interested to find a Manifesto, comprising 18 points, starting with:

> 1/ mythogeography is an experimental approach to the site of performance (in the very broadest, everyday sense) as a space of multiple layers.
>
> 2/ it is also a geography of the body. It means to carry a second head or an appendix organism, in other words to see the world from multiple viewpoints at any one time, to always walk with one's own hybrid as companion.[1]

These points resonated with me and I began to warm to the book. On my walks I had indeed begun to see 'multiple layers' in landscapes around me, for instance the way officially-planned public and commercial spaces were crossed with 'desire paths' etched by the way people actually walked; the strange symbolism created by combinations of discarded objects; the hidden narratives that waited beneath the surface of just about anywhere. It was clear that I walked through places with 'multiple viewpoints', as a repertoire of contrasting selves, spawned by roles I played (husband, employee, writer, online banterer, patient) and the places where I played them (towns where I had lived, galleries and university campuses where I had worked, pubs I had frequented). And recent personal events had made me keenly aware of the 'geography of the body'.

Outside the train window, seen from above, a cluster of buildings: a small castle, a church, a manor house walled with yellow stone on a wooden frame. "Do you know what that castle is called?" asked a fellow passenger, a young American woman. I recalled the many visits made to the place, when my wife Jennie and I lived in nearby Wolverhampton. Visiting heritage places a hobby we had discovered together; the period when we were members of both the National Trust and English Heritage; weekend freedoms; a respectable pursuit for grown-ups. Sometimes we would arrive at those buildings and there would be an event happening there with wooden swords, painted shields and a hog roast. Not really a castle, a *fortified manor house*, built during peacetime, the 'castle' form merely an

[1] See Appendix One for the complete Manifesto.

echo of long-ago wealth and power, stamping its presence into the borderlands. Now maintained with public funds, anyone with the price of admission could walk through it and peer at its formerly-private inner spaces. "Yes, it's called... er... wait... no, I can't remember, sorry. It's great though if you get a chance to visit."

I read more of *Mythogeography*, the text returning to a collage-like mode, my eyes roaming the pages, feeling somewhat overwhelmed by the mass of information. It seemed that this 'mythogeography' wasn't an attempt to rebrand, update or improve on 'psychogeography', or to launch a new movement. Whoever wrote this aimed, in a generously playful way, to provide a "toolbag of ideas" for "mis-guidance", an "invitation to practise, to share and to connect" ... "connecting the diverse layers and exploiting the gaps between them as places of revelation and change" (110-116). I experienced a slightly delirious sense of there being worldsful of stuff to explore. A reference to comic books caught my eye, an interesting little passage, something about Captain Britain... a passage which I realised I had written myself. Yes, there was my name – how did that happen? Hah! A quote from my blog, obviously...

Amused, I read on a bit more. Three pages later, there was an illustration of a handwritten 'List of Exemplary Ambulatory Explorers'. I read down it, recognising some artists, authors and activists as well as unfamiliar names.

Stephen Graham

Kinga Araya

John Davies

Maureen Stone

Ninjalicious

Tim Edensor

Townley and Bradby

Walk & Squawk

Kate Pocrass

Arthur Machen

Stalker (Rome)

Wrights & Sites

Manchester Zedders

Peace Pilgrim

Roy Bayfield...

...blimey! I was in this as well! Was I going to be on every page of the book? Well, no, those were the only references to me. But it was pleasantly weird to find myself there, in such a group. Peace Pilgrim walked 25,000 miles; John Davies's *Walking the M62* (2007) had inspired me to start the whole business; Arthur Machen wrote of the unutterable and inspired people from H. P. Lovecraft to M. E. Smith. Not a bad pantheon to join. Also, unlike the male lineage of 'standard' psychogeography, this strange-sounding crew featured assorted genders.

Buoyed by the fact that one of my multiple selves had an independent life, mythologised in a volume written by persons unknown, I sat back for the rest of the journey to Cardiff in a kind of energised funk. The reality-challenging nature of the text made finding myself in this particular book feel more than just a mention – in some bizarre way I had become part of it. Obviously I didn't *only* exist in the book – I wasn't about to see through the fourth wall, beholding a giant pen-wielding hand hovering over the Long Mynd, writing my script – but some aspect of me was alive within its pages. An odd occurrence that I filed away along with the many other synchronicities experienced in time spent in non-functional walking.

The exhibition I was going to see was of paintings by my friend André Stitt, whom I had known for 30 years. The work on show in Cardiff was the results of a residency he had done in Craigavon, Northern Ireland – exploring the 60s new town, cycling its "sixty miles of secret pathways" (Stitt et al., 2009: 20), drawing large maps, diagrams and texts and then painting over them, a performance creating paintings from layers of place.

> It's here that my own experience of Craigavon has taken me. Here where the autumn sunshine comes steaming through the underpasses like portals into another world. Here, and in all the spaces between. All those strangely intimate spaces of woods and lakelands, of debris and residues, of demolished housing estates... It is in these spaces that I have most assiduously felt the spectres that haunt Craigavon and now, in some small way, sincerely attempt to almost reveal before they almost vanish. (ibid: 20)

I surprised André, appearing unannounced at the exhibition preview after a 20-year gap in meetings, as if walking through a hole in time. I hung out

with him at the exhibition for a couple of hours then left, arranging to meet up again the next day.

Drifting back to my hotel, I wandered the streets of Cardiff, peering up at buildings illuminated by long strips of coloured light and giant digitised faces on electronic billboards. In the back corridor of a pub, some old black-and-white photos were largely obliterated by areas of black mould as if the streets had been subject to some kind of ancient dark incursion of the kind described in Arthur Machen's *The Great God Pan*:

> I watched, and at last I saw nothing but a substance as jelly. Then the ladder was ascended again ... [here the MS. is illegible] ... for one instance I saw a Form, shaped in dimness before me, which I will not farther describe. But the symbol of this form may be seen in ancient sculptures, and in paintings which survived beneath the lava, too foul to be spoken of ... (Machen, 1894/2006: 62)1

In the website for André's exhibition, a tiny phrase: "Our destiny is to vanish" (Stitt, no date).

That was six years ago. I carried on making pedestrian journeys, accepting the commission to be an "ambulatory explorer" as it had said in the book, or someone "wandering around like David fucking Carradine"[2] as my friend John Mainstone put it. Adopting an identity as a walker. But when I look at this identity I don't just see a single image, a jaunty icon of a pedestrian from a road sign or map, a lone figure in a landscape. I don't just see me at all. The remembered roads have various Roys on them – pilgrim, patient, psychogeographer... and less defined figures.

I decided to reflect on my walks, search amongst the signs and wonders of my various journeys for clues – what are these walking identities? Where might they have come from? Where are they heading? Can I name them?

I have walked for many reasons – as creativity, as spirituality, as a route back to reality, to get to work and go to the shops. Connections that can only be made on foot, things best seen from a pedestrian viewpoint, sneaking backstage in the spectacle of the everyday to glimpse the inner workings. Walks to make sense of uncertain times. So gathering up the shredded maps to make a new one, I wrote this book.

[2] Carradine played a martial-artist monk wandering the American Old West in the TV series 'Kung Fu', originally broadcast 1972-75.

What You Are About to Read

Each chapter starts with a quote from *Mythogeography* (2010), specifically from the '**Legend**' given in that book – 'legend' as in a set of definitions of symbols used on maps to define landscape features. I have used these quotes, in their original order, to organise the material used in this volume.

The main body of each chapter comprises an account of a walking journey I have done. These are not chronological: structuring the book around the mythogeography Legend has (dis)organised the walks into a sequence that wanders in and out of time.

I then reflect on a **Landscape Feature** I have encountered that corresponds to the Legend – exploring the workability (or playability) of mythogeographical concepts and illustrating how they have manifested in one person's (my) actual walking.

The **Walker's Role** sections are reflections on the pedestrian identities manifested in the walk in question.

Finally, the **Jump Over the Back Fence** notes are hints towards further actual walks which could be made. (The heading is based on a quote from the naturalist John Muir, who famously indicated that to prepare for a trek he would "throw bread and tea in an old sack and jump over the back fence" (Muir, 2001, p. xii)).

Existing knowledge of 'mythogeography' is not necessary to read this book, though further exploration is highly recommended.

One: Walking to the Green Heart

Legend

 Crowhurst Computer – when Donald Crowhurst's boat 'Teignmouth Electron' was found abandoned in the Atlantic, rescuers discovered that wires from all the gadgets on the boat ended in a tangle. Crowhurst had never found the time to install a computer. This symbol depicts a 'body without organs', a multiplicity without an organising principle.

– *Mythogeography* (2010: 12)

2010

I lay on the gurney, being pushed through the hospital corridors, fast and businesslike, not an emergency dash but a routine movement in the day-to-day work of the hospital. I glimpsed an empty garden space through a window, planted with slightly unkempt shrubs, herbs beginning to bolt under a weak sun: a corporate Zen-space of gravel and pebbles. In a few minutes I would be unconscious. Shortly after that, my heart would stop beating, my torso would be splayed open, hands and devices would start work. Would my soul remain in the body? Merged with machines, a cyborg, would the entity on the operating table actually be alive? Would I even wake up? I was not certain about these things. And I was even less certain when, how and in what form I would complete my walk to Brighton.

Two years earlier I had started travelling on foot, a bit at a time, from Southport in North West England to Brighton on the South coast, planning to arrive before my fiftieth birthday. Starting from where I lived and walking back to where I had been born, it was a return to the source; rewinding my own history. By walking over months and years, taking expedient routes rather than seeking out tourist highlights, I was seeing my own country close-up and without preconceptions, an ongoing revelation of the land I lived in, my personal Matter of Britain. Tracts of territory formerly glimpsed from car windows had become the intimate, mud-and-sweat sites of day-long hikes and sources of bizarre discoveries. Along the way I had (literally) branched out with side-trips, diversions, looping additions to my

route and playful experiments in pedestrianism, all happening alongside my 9-5 office-centred life as marketing director for a university.

In making this journey I had reached a village in Berkshire near Slough called Langley; specifically, Langley station on the Great Western line into London Paddington, in late November. A few weeks later, on the morning of New Year's Day, walking near my home through a chilly dawn I noticed many yards of unspooled videotape in a frosty hedgerow, leading to a broken VHS cassette of Disney's 'Fantasia'. I also noticed a persistent cold pain in my chest. By the end of January, I had been diagnosed with angina, caused by blocked arteries, and told I urgently needed a quadruple cardiac bypass operation. I went from being a guy happily walking 25 miles in a day, to one who was advised not to run up stairs and prescribed assorted pills and inhalers, together with open heart surgery. A kidult with an old man's disease. The scope of my journey had reduced from England to the inner workings of my own body. So I came to be in Broadgreen, proper name Liverpool Heart and Chest Hospital, preparing to be spatchcocked on an operating table, heart set aside and stopped, lungs pumped by machines, and veins transplanted to bypass the life-threatening blockages.

Early on in my journey I had, unknowingly, walked past Broadgreen while entering Liverpool along the Loop Line, a long path in a former railway track, cut deep into the ground, contained within cool green walls of rock fringed with trees that curved above me as I strode along. I saw some huge graffiti, painted with brushstrokes rather than an aerosol, saying either WALKERS RULE or WALKERS ROLE. The hospital had been just a few metres away as I strode towards the city, hundreds of adventure-miles stretching before me. As I lay in the hospital I still felt connected to my route. A brief stroll, theoretically achievable in a dressing gown and slippers, would have taken me to the path linked to all other paths, my own personal ley line.

But for now, this and all other possibilities were shutting down. The South Downs of my destination had receded into a dim occluded future: what was here now was just this hospital wing, a journey along a brightly-lit institutional corridor, muted on pre-med, surrendered.

The gurney pushed through the doors into an antechamber to the main operating theatre. People were bustling about, doing things with equipment, which for them was just part of their working day. The surgeon gave me an appropriately hearty greeting, with a twinkle in her eye as if she knew of something splendid about to happen. The anaesthetist chatted amiably, distracting me from the discomfort of drug-lines being inserted

into my neck. He told me what his son was planning to do after he finished college; I started saying something in reply, opiates flooded my bloodstream and the twin ravens Thought and Memory fell past the horizon.

When I first went to my GP, I had been sent for a treadmill test, to 'rule out anything cardiac'. This had been set for a couple of weeks later, at the start of a short holiday. I planned to get the appointment done, then walk around Southport a bit, exploring some of the streets that were named after places from my ultimate destination, such as 'Sussex Road' and 'Brighton Road'.

The treadmill turned out to be similar to those used in gyms, only with wires stuck to one's chest and lie-detector lines being drawn on screens and paper. I was advised not to look down, but instead to focus on the noticeboard filled with holiday postcards at eye-level in front of me – cheerful, slightly faded, with a blue cast due to the enduring quality of cyan ink relative to the other colours. The stationary walking felt good, but just as I was beginning to get an exercise-endorphin-buzz the doctor told me to stop. He invited me to sit in a chair, told me that I had angina, gave me a prescription for several tablets and said I would be booked in for an angiogram in a week's time.

I decided that I might as well still do the trip I had planned, and hiked along Sussex Road in the chilly sunshine. I ended up in Southport, bought a pint in a pub called the Guest House, sat in the front bar where the afternoon sun moved slowly across the wood panelling, and started making phone calls to tell people about my newly-revealed health condition.

No longer a long-distance walker, I was now someone facing open heart surgery, carrying a nitro spray to use in case of chest pains, one night collapsing in a restaurant. I had no idea what this would mean for my expedition. Perhaps the rest would have to be accomplished in 30-minute sections, assuming I didn't expire under the cardiac knife, which was apparently a five-percent, or one-in-twenty possibility.

In the event of death, I planned (as far as one can plan such things) to symbolically project my essence towards the end of the route, to inhabit the gorse-covered Downs I remembered, but could no longer reach. I used this as the basis for a poem, which people liked, leading me to plan to write more – writing would be my project, before and after the operation. I decided to riff on a 'wounded healer' archetype, devising a title, *Bypass Pilgrim*, and scribbling notes while preparing for the hospital stay.

My friend Ian Smith, visiting Liverpool to get a hurdy-gurdy fixed, arranged to meet me in the Walker Art Gallery. I had last seen him ambling

purposefully through the crowds on Liverpool Hope Street at the 'Market of Optimism', a large-scale piece of street theatre devised by Mischief La-Bas, the performance company he ran with his wife and partner-in-crime Angie Dight ("Gently warping the underlay of the fabric of society"), dozens of stalls lining the street that runs between Liverpool's two cathedrals: Heavenly Estate Agents, Magic Lamp Sellers, Guardian Angels and King Kong Konfidence. Ian had been moving through the audience, a secret shaman keeping an eye on the sidelines, a tall man in a glaring orange-check coat, sharp grin framed by trademark tick-shaped sideburns, eyebrow raised in endlessly appreciative irony.

I had known Ian for decades, during which he had adopted many performance guises: Vagabond King, Minotaur, ringmaster, artist and provocateur in countless situations, from giant festivals to pub back rooms. We had escapade-form together: "We're all history, baby!", as he wrote in a web post about his 80s-era band 'Birds With Ears' (Smith, 2007.)[3] Now he was sitting in the Walker, detouring to meet his old mate before I went under the knife. We chatted; live art, clothes, friends. How details mattered: a dirty t-shirt could ruin a performance, or be exactly the right thing. Seeking the toilets, I picked my way slowly up the steps to the first floor, arteries silted up like Neston estuary, its once-busy ports abandoned to encroaching saltmarsh: drastic new routes needed.

A booklet about the surgery described the recuperation process. Apparently walking around the ward was encouraged, with milestones prescribed, coloured hearts on the walls signifying the target distances. 'Day Three: Walk 8 Times to the Green Heart'. At this moment I began to feel OK about things. They were talking my language. If it was essentially a walking project, I could get the job done.

The day of the operation came. Jennie and I drove there on a Sunday afternoon, subdued, following a driving route that normally began pleasure trips and holidays. At the hospital, I checked in to a reception ward. Having heard so much about the great Broadgreen, the normality of the ward – radio blaring, many patients – came as a surprise. A sign saying BE HERE NOW lent a Buddhist air to the process. Body hair was shaved, and a disinfectant shower gel provided. The process involved successive surrender of everything – clothes, possessions, control, dignity – and then consciousness. Eventually Jennie had to leave me to sleep. In the early

[3] A phrase I would later have printed on a set of badges made to give to friends at his funeral.

morning, docile with sedatives, I took the required shower. Jennie came back from the nearby accommodation for patients' families. It was time. I had been given the coveted first slot of the day based on my high-risk condition. I said goodbye and was wheeled off to the operating theatre.

I slept 24 hours after the operation, occasionally thrashing my limbs as if climbing out of a pit. Then I was awake in the science-fiction space of Intensive Care, tubes and dressings all over me, able to talk, but only in a whisper. I had had five bypasses, one more than the expected four, but I was OK.

The nurse gave me a cup of sugary tea in a baby's sippy-cup. This was nectar. Soon afterwards I had some cornflakes, another magnificent experience.

Tubes were pulled out of me – I was Captain Picard having Borg-parts removed. Drains from my chest, catheter and (worse as it involved being half-strangled) one from the neck.

Hours passed, though in a kind of smooth emulsion of drugged time.

In another bay, an elderly man was sitting. We nodded to each other. Later he was gone. I asked the nurse who he was but he said there hadn't been anyone there.

Jennie came. In the afternoon I was moved to the recovery ward, and (in my new dressing gown and slippers) made the first walk, heading to the toilet with what Jennie described as "tottering, old-man steps".

There is a hollowness to the experience of being in hospital, lying for long hours outside of time. The normal rhythms of life are suspended; there is wakefulness in the night and sleepiness in the day, sunk in a cocoon of lassitude, feebleness and boredom. Nothing you have ever done, thought or known really matters there. There is nothing *to* do, at least nothing that means anything. Medical tasks and tests are mostly to gauge what the body is doing by itself. You can be friendly with the nurses – an accomplishment of sorts – but as they would treat you just as well if you were vomiting and cursing, this is an arbitrary achievement. The nothing, the corporate space of hollowness, stretches on. Things happen, but it's just stuff. You might think, following the rules of fiction and drama, some vast sin or spectacular catastrophe brought you to this state. But no, that was just stuff as well – the ice age of cause and effect – every person, every cell and molecule, suspended in the grey glaciers, the stories we thought we had, thought we *were*, proven to be just scratches in the ice.

I did the prescribed walks to coloured hearts in the ward, without any problems. I was slightly disappointed that the hearts were just A4 sheets, the

hearts depicted with clip art, pinned to ordinary noticeboards. I don't know what I had expected, just something a bit more solid and definite. But still, I followed the instructions.

Although the route of my journey to Brighton lay only a few hundred yards away, the idea of wandering out to touch the soil of the path now seemed no more feasible than a pilgrimage to Rome. In terms of unlicensed wandering, the best I managed was a trip along the corridor to fill my own water jug, a brief moment of anarchy. The weight of the full jug made the wound in my chest ache, but it was worth it for the moment of self-determined action.

Dressings were removed, revealing scars. On my left forearm and lower left leg, two long cuts had been made to enable veins to be removed to recycle as the bypasses in my chest. These scars were curved, making angry red contour lines in my flesh. The chest scar, right up the middle, had a gathered puckering at the top, making a sort of arrow-head pointing at my face. The whole chest was tingly and sore. There were also two small scars on my belly where drains had been run into my body cavity. They looked like bird tracks in snow.

Climbing up and down some stairs was the final demonstration that I was fit to be released. On Easter Saturday, we made our way to the car across a grass verge now blooming with crocuses. Crossing the invisible border back to non-institutional life, back to wearing adult shoes, I wept in the spring sunshine.

I recovered at home, undertaking daily walks of prescribed, increasing durations – 5 minutes, 10, 15. These little jaunts were quite challenging at first. Climbing the local hills that I had previously dismissed as unworthy of being called 'hills' became a worthwhile achievement.

I wrote the poems to fill my planned *Bypass Pilgrim* book, working out the number of pages required for a typical slim volume and writing to fill that space. I began to feel fitter than I had before the operation, as if each breath had more oxygen than it used to – it was like moving to another planet with a lighter gravity and richer atmosphere.

Having rapidly entered the health system, I was steadily to leave it via a series of meetings – discharged by the hospital, discharged by the cardiologist, completing a series of rehabilitation exercises.

At the final meeting in Broadgreen, I expected to meet the surgeon again for the last time, and have a suitably meaningful farewell moment with the individual who, next to my mother and my wife, had been the person most intimate with my body. I waited in a small room, and saw a young female

doctor I had never seen before. She summoned the video from my angiogram onto a screen – a misty monochrome movie of my pre-op heart beating. The veins looked like winter twigs, kinked around the dark nodes of the blockages. The doctor explained that, during the operation, "depending on your philosophy you were dead for a while". This made sense – with my body shut down, in what sense had I been alive? Perhaps as a pattern that would re-member itself when blood- and oxygen-flow were restored. The wintry image on the screen reminded me of black and white Universal horror films from the 30s – 'Frankenstein', 'The Wolfman' and the ridiculous ones with Abbot and Costello.

The spring was a pleasant time to be convalescing. Writing in our back room day after day was a sort of enforced sabbatical. I listened to birdsong in the morning and watched the garden fill with blossom. I had asked the doctor how long the grafts would last. The necessarily cautious, official answer was a disappointingly low number of years. Having got over the hurdle of the actual surgery, done all the exercises, taken the tablets and adjusted my diet, it seemed unfair that everything was not fixed forever. But this was not the case – I seemed to be in a part of life with death at the end of it. So here we were. I looked into religion for an insight into how things might work, but nothing I read seemed to offer any ground on which to stand. It remained an open question.

Daily exercise walks were longer now, exploring the surrounding countryside that we had never really visited before. The flat landscape of low hills, canals and cabbage fields had a beauty that I had never appreciated, being a Sussex Downsman in exile. Now this flatland was becoming home.

Still I yearned to resume my DIY pilgrimage, to regain purpose and distance. Still the sound of my heartbeat seemed massive. It almost seemed to be shaking the bed. Systole and diastole, contraction and expansion – forces I had not considered while my heart beat away unnoticed, billions of times – now seemed huge, encompassing the universe. Seasons, tides, the movement of galaxies all happening in vast rhythms – and me awake in a grey dawn, watching for movements that might extinguish me, whatever 'I' was.

I completed the *Bypass Pilgrim* book. I had filled the last page with a poem based around 'fives' – five bypass grafts, the Five of Hearts, Five of Cups, fifth dimension, fifth element and so on. The poem seemed to be implying that I was no longer entirely certain that I was actually alive anyway – an emptiness in the heart of a tangle of routes, trajectories, connections.

Finally, after months envisaging the restarting, I resumed the journey at the point where I had so casually finished the preceding November. I was

spending the day walking with Jennie for the first time on this journey. We drove to Langley Station, the precise spot I had reached on the last, impossibly innocent outing. All these months unable to be there physically, I had been metaphorically stalled on this spot. Still in rehab mode, this walk was relatively short, taking in some Grand Union Canal and part of the London Loop. If I was the most important element of the landscape, if everything revolved around me, then the growth of blanket weed in the canal, the fading of paint on the narrowboats and the additions to graffiti on the underpasses would have been measured to quantify my absence. The St. George flags on the new canalside apartments would be there to celebrate my slain dragon. But none of these things were the case so we were free to just walk and notice: meadows visible through the hedges; a heron, with a whole fish in its neck; features of rail and canal architecture collapsing into the natural environment; empty chairs at the back of a factory.

At one point I climbed up a bank to scan the M25. There in the hidden angles of the roadside a secret dust had gathered, like a silver fur, hidden from the view of drivers.

My geography, which had collapsed into the outline of my own body and there become a strange new territory, was now expanding again – systole/diastole. Altered body expanding its range into an altered landscape.

There were dragonflies and it was nice to be in the sunshine.

Landscape Feature

In my ill-body, all reference points dissolved until I was in a landscape that comprised 'a multiplicity without an organising principle', my own organs rendered uncanny. I recognised the 'Crowhurst Computer' in the shifting and uncertain form of my own physical presence. On the face of it, Donald Crowhurst, disappeared at sea, seems like a tragic figure. His boat proved ill-equipped, the non-existent 'computer' a case in point. However, Crowhurst did succeed in becoming myth, and is in a sense always still returning – the empty computer the perfect device for navigating the void.

Walker's Role

The Returner

In these walks I was walking back from somewhere, returning...

Returning home.
Returning from sickness to wellness.
Returning from the nowhere of the anaesthetised state, from the distance of the Prodigal Son town, from temporary separation from the Beloved.

An heroic exemplar of The Returner is Herbert White – mangled beyond recognition in a factory accident, Mr White made a celebrated two-mile post-mortem walk from cemetery to parental home ('Laburnum Villa') where he knocked vigorously on the door, seeking admittance (thus becoming the original 'one who knocks') after which nothing more is known of his journeyings – as recounted in *The Monkey's Paw*, written in 1906 by W. W. Jacobs.

Jump Over the Back Fence

Return Walks

❖ Walk back to a point of origin, perhaps where you were born; or where something meaningful occurred; or an earlier state or stage such as 'innocence' or 'Oz'.

❖ Devise an epic pedestrian method to Return to Sender an undesirable object or concept.

❖ Notice how time speaks when you walk forwards in order to go backwards to something in the past.

Two: Out With Baby

1907-2012

"I don't remember seeing Portslade on the radar screen..." wrote Robert Sheppard in his chapbook *The Given* – a moment forgotten by the writer but remembered in a journal entry from an earlier decade. Robert was raised in Southwick, the town next to Portslade, and such dismissal is perhaps to be expected from the rival place, across the border in West Sussex. Admittedly, Portslade may not be on many people's radars, at least not consciously so.

In Ian Fleming's novel *Thunderball*, published in the year I was born (1961), the character Domino Vitali provides an interesting account of the origin of an iconic image: the sailor on the John Player Navy Cut cigarette packets: "Have you never thought of the romance behind this picture? You see nothing, yet the whole of England is there! Listen...This is the story of Hero, the name on his cap badge."

A career sailor from boyhood, "he went all over the world – to India, China, Japan, America. He had many girls and many fights with cutlasses and fists." Rising in the ranks to become a bosun, he grew the famous beard and embroidered a picture of himself, framed by a lifebelt. Then "he came back home on a beautiful golden evening after a wonderful life in the Navy and it was so sad and beautiful and romantic that he decided he would put the beautiful evening into another picture" featuring "the little sailing ship that brought him home from Suez" and "the Needles lighthouse beckoning him in to harbour". Hero hung the embroideries in the pub he ran, where one day a Mr John Player and two small boys, his Sons, saw the pictures. The rights to copy them were acquired for the sum of a hundred pounds, and combined into one – the round portrait superimposed on the square homecoming picture, the reshaping obscuring a mermaid – thus creating

the image that has adorned Navy Cut packets ever since. As a child at Cheltenham Ladies' College, Domino (at that time called Dominetta) carried the picture around with her, as a talisman, "until it fell to pieces".

This account could of course be made up – a tale within a tale. There are other origin stories. Various sources (e.g. Middleton, 2004) refer to a sailor called Thomas Huntley Wood as the subject of the image. Wood's picture had appeared in the *Illustrated London News* in 1898 "whence it was borrowed for advertising purposes. A friend of Wood's wrote to the firm suggesting payment of a fee of £15; Wood reduced this to a sum of two guineas 'and a bit of baccy for myself and the boys on board'" (Yakob, 2015). Wood lived in Lower Portslade, as far as I know until he died in 1951. Apparently he tired of the recognition and shaved off his beard. There are other claims for the original sailor. Perhaps many places have a story of 'their' sailor who was used as the basis for this picture, like the countless local versions of Hindu deities, or the Madonnas in trees that appear throughout Europe. But as a Portslade man brought up on James Bond (of whom my dad approved on the basis that 'the story starts straight away') I'll stick with Thomas Huntley Wood for reality, Domino Vitali (aka Dominetta Petacchi, renamed Dominique Verval in the 1965 film, renamed again Domino Petachi in 'Never Say Never Again') for mythology.

I once worked in a newsagent a few streets from where the sailor Wood lived. I remember trying Navy Cut, which were tipless and delicious. However, the black-packeted John Player Special, known as JPS, were the cigarette of the day, so much so that if people just asked for '20 fags' that was probably what they meant. These just tasted like burning paint to me. (When the KGB produced a miniature camera disguised as a packet of cigarettes, plainly the popular JPS were the model). Around that time JPS produced black sponsored Lotus Esprit cars to celebrate racing victories: an advertising technique that probably cost them more than the two guineas and some tobacco used to buy Wood's face. The Esprit had at that point enhanced its fame by appearing in a James Bond film, 'The Spy Who Loved Me'; in the film, the car was able to convert into a submarine. I misremembered the dialogue about the cigarette packet artwork as being from *The Spy Who Loved Me* novel rather than *Thunderball*. Had I scrabbled around in the attic to find the book to quote from, I would have been looking for *The Spy...* In any case, James Bond himself seems unlikely to have visited Portslade, through another heavy-drinking orphan did...

Twenty years before *Thunderball*, in the 1941 novel *Hangover Square* by Patrick Hamilton, the protagonist George Harvey Bone suffers from a

personality disorder involving long amnesiac spells. In one of these he finds himself wandering an unknown street, and asks a passer-by where he is. Initially he mishears 'Portslade' as 'Port Said'. This scene highlights the disorientation of lost identity, and maybe also reflects the nature of the locale, as Portslade itself has been described in 1929 by R. Thurston Hopkins in *Kipling's Sussex Revisited* as "a place with a dual character: a veritable 'Dr Jekyll and Mr Hyde' of a place. Portslade Hyde is painfully brutal with its squalid water front and rows of grimy houses and shops, while Portslade Jekyll, a mile from the sea, is a benevolent spot and just as pretty and secluded as nine out of ten of the 'guide book' villages" (quoted in Green, 1994).

However, Portslade has never quite accepted a role as a dystopia. For instance, a spurious crest for the town, designed in 1920 by P.J.W. Barker, who owned a shop a few doors up from the newsagents I worked in, comprised "A Bunch of Grapes signifying 'Health'... An Oak branch signifying 'Strength'" and a Latin motto "which being freely translated means 'Here's health and strength to you'". "PORTSLADE HAS BEEN FAMOUS FOR HEALTHINESS FOR OVER 100 YEARS" points out the enterprising druggist, citing the *Brighton Herald* and the fact that the town had sometimes "had the lowest death rate in the kingdom" (Green, 1994: fig. 116).

And healthy effects have been experienced. I have a picture postcard, post-marked PORTSLADE AUG 16 07. The sender was writing from Trafalgar House, another building a few yards from 'my' newsagents. 'I have been out with Baby this morning from 9 till 11.30, went down by the sea, it was lovely there, I am enjoying myself very much, and certainly feel better' wrote 'B' to a Mr F. H. Brookes or Brooker, 48 Tavistock Road, Westbourne Park.

I hope things worked out for B and Baby. Her postcard featured, incongruously enough, a picture of Orkney. A year later, she would have been able to buy a postcard of Portslade itself, bearing an image with something of the surreal power of a Max Ernst collage: a woman kissing a man, her face replaced with the hair of the back of his head and an ambiguous, even terrifying caption: "Dear_____ I have no face to tell you all that happens in Portslade" (Middleton, 1997: 4).

Over 100 years since the outing with Baby, three-score-and-ten after *Hangover Square*, half a century after *Thunderball*, three years after I started walking down from Merseyside, I arrived at Portslade, having travelled some 300 miles, occasionally limping as, like Domino, I have one leg slightly shorter than the other (though given Ian Fleming's penchant for giving characters physical flaws, which tend to make women/good

characters more attractive, and men/bad characters more monstrous, this may have been an aspect of his fictionalisation of the actual events). If I had recalled the Portslade crest at the time of my heart operation, I would have used it as a talisman of health and strength; the link with my distant home town would have been comforting. Perhaps subconsciously I did recall it; personal ley lines seem to join up all that happens, even as things transform into other things, names and faces change and talismans fall to pieces.

Landscape Feature

Fault lines are fractures in the earth. Masses of rock slide past each other, their movements causing seismic events. The earth shakes, buildings fall. In 1930, pregnant with my father in Japan and caught outdoors in an earthquake, Granny Bayfield followed advice to shelter beneath a eucalyptus tree, the idea being that the tree's broad root ball would hold a platform of land together. It worked. Soon afterwards she moved back to England and my dad was born. Later we lived in a house where East meets West Sussex. Faults make lines on the landscape, potential paths, 'trajectories' along which humans can walk. Faults' own movements also make trajectories – layers of rock, moving horizontally ('strike-slip'), vertically ('normal') one on top of another ('reverse' or 'thrust') or apart ('oblique') – journeys made in geological time.

I take a 'mythogeographical fault line' to be a fracture in the mythosphere, realised in material space. As a child, the border between East and West Sussex, Portslade and Southwick, running at the back of our garden, defined by a footpath and a row of electricity pylons, seemed like such a line. Merely by virtue of being on the other side of the line, Southwick seemed slightly uncanny. The line/path could take me from the back of our home to the gorse-covered Downs, an open and numinous landscape of Mount Zion, Thundersbarrow Hill, Crooked Moon Hedge and Skeleton Hovel. Eulogising my place of origin (because no-one else is likely to), I follow 'thematic trajectories' – fault lines between memory and fiction, the Fields We Know and Beyond, myth and geography.

Walker's Role

The AutoBioGeographer

The AutoBioGeographer walks their story, and in so doing sees it with fresh eyes.

This kind of walking is Auto*Biography* – working on a self-created story focused on oneself. It is also Auto*Geography* – an exploration of the geography of the self, the geography of 'you' as it operates in space and land. And it is Auto*Bio*Geography, undertaken with a physical body that is part of an ecosystem interacting with space.

This can be merely narcissistic, or it can be a form of self-development– stripping away inessentials, following the advice of the philosopher Plotinus to "never stop sculpting your own statue, until the godlike splendor of virtue shines forth to you" (Hadot, 1998: 21).

Jump Over the Back Fence

Walk through your personal geography, experiencing it as the discovery of new territory filled with marvellous insights into a beautiful stranger.

Three: My Life in 'Spoons

Legend

A McCurdy – a small-time criminal (his final loot was described at the time as "the smallest in the history of train robbery"), Elmer McCurdy was gunned down by a posse in Osage Hills, Oklahoma in 1911, his body embalmed and displayed as "The Bandit Who Wouldn't Give Up". Decades later it was found, under layers of paint, a looming 'dummy' ghoul in a Ghost Train. A McCurdy is something that was one thing, but is now another.

– Mythogeography (2010: 12)

2008 (July)

It was drizzly as I drifted through the market street in Stone on a July Saturday morning. I had arrived by train, missing a connection and getting generally stressed in the rain. Still, it was only 9.30. I had decided to call the blog post about the day's walk 'Beer-to-beer Networking', a lame pun on 'peer-to-peer networking', the Internet filesharing system made famous by music sites such as Napster. To activate the pun I washed down a cooked breakfast with a pint of IPA in Stone's Wetherspoon's pub, a converted Post Office…

2008 (September)

Laden with confused self-pity, I walked on, through Wordsley and down to Stourbridge, where I lived for six months after the 'forgotten' marriage and before moving back to Wolverhampton. The town had moved from shabby-genteel to outright decay, or so it appeared to my increasingly jaundiced eye. I walked up the High Street. A shoeshop proprietor was talking Freemasonry with his customer. Seeking an end-of-walk drink, I entered a pub built in the house of a 19th-century merchant. The building seemed to go on forever, a multi-sectioned Inferno of drink, cheap food, enormous displays of colour-coded condiment sachets… this was the local Wetherspoon's…

2008 (October)

From Brierley Hill, I walked down to Merry Hill along new roads, much around me still being built... Back in the '90s, I was fascinated by the Brewer's Wharf when it appeared, a pub new-built from old bricks – a novelty at the time. This kind of salvage-themed hyper-reality is common now... I had a fancy to finally visit the Brewer's Wharf, but peering into the window at the chilly-looking chrome beer pumps I wasn't drawn. A nearby Wetherspoon's formed part of the Waterfront development... (See Chapter Eight.)

2009 (July)

Seeking cheerful energy, I played a song I remembered as a fun summer tune, the Piranhas' version of 'Tom Hark' – but in my enervated dawn state it sounded like some kind of seaside apocalypse. I rallied as we approached Banbury. I had assumed that I would walk out of Oxfordshire into Buckinghamshire, but looking at the map on the train I realised that I would actually be spending most of the day in Northamptonshire. This bothered me as I liked to have some kind of image-fuel for the journey, a sense, however tangential, of the mythology of the place I'm walking through – otherwise all I'd be doing is looking at scenery and thinking things like 'yes, that is a hill'. I put out an appeal on the aether and got a recommendation in the form of a query: 'John Clare?'. This led me to seek out Books & Ink, a pleasant bookshop that did indeed have some books by Clare, agricultural labourer and poet, b.1793 d.1864. Armed with reading material I adjourned to The Exchange, a Wetherspoon's pub in a building that had once housed a telephone exchange...

2010 (July)

In late July I was back to solo walking, on a hot, heavy day with occasional downpours. Walking between vast reservoirs, deafened by planes taking off from Heathrow, crossing and recrossing the M25. Aroma of camomile rising from soaking, hot fields. This was the secret life of the motorway margin: pollution control reed beds, teeming wildlife, men in vans belonging to utility fleets lurking in fly-tipped spaces at the ends of lanes. As has often been the case on this walk, many forms of transport seemed to be braided together – rivers and roads meeting at a place called Mad Bridge beneath the Heathrow flightpaths while horses look on impassively.

I skirted Staines Common, where commoners once had rights of pannage (running their pigs on the land), and entered Staines itself, where I met up with Jennie in a handy Wetherspoon's pub on the site of an actual inn…

2011 (July)

I reached Llandudno, like Saltburn and Southend a place I had never previously visited. In Waterstones I scanned the 'local interest' section, learning that Alice 'in Wonderland' Liddell used to have holidays here. I went to Wetherspoon's Palladium, a vast converted theatre that has also been a cinema and a bingo hall…

2011 (August)

Apparently there were Eric Ravilious murals inside the pier pavilion. I could not see these, but a few minutes later I was admiring a mural painted on the space where the screen would have been in the nearby Princess Cinema, now converted by the J. D. Wetherspoon chain to the Picture House pub. I found the chain endlessly fascinating as well as useful. The combination of their hugeness, cheapness, decor and range meant that any given 'Spoons can combine the roles of pub, café, restaurant, old people's day centre, sports bar, perpetual beer festival, tramps' hostel and unofficial branch of social services, often without any obvious clash. The perfect place for an anonymous, utilitarian drink. I also had a voyeuristic pleasure in the hazy, alcohol-infused, almost subaquatic atmosphere that pervades them at odd times of day, being part of a crew of alconauts drifting into tipsiness within a comfortable space fortified from the bright and sober world beyond.

A TV screen showing news glimmered beneath the mural, relaying soundless accounts of riots unfolding in London. While I roamed the coast archly observing transformations effected by tourism, regeneration and the Wetherspoon corporation, currents of protest, greed and violence were transforming city centres in other ways. Over the coming hours and days, many of us would find our concepts of the city and 'England' pulled apart, requiring reconfiguration and repair. Lens flare in the video capture of burning cars and buildings formed shifting areas of white-out on the TV, cutting through the special gloom of an afternoon drinking session. A subtitle saying 'let's get more on the Eurozone crisis' had jammed on the screen, making a collage-connection with larger forces. It was still there when I finished my pint and left…

Landscape Feature

The Wetherspoon's pubs that used to feature regularly in my walks are, in an obvious way, examples of 'something that was one thing, but is now another', as many are sited in repurposed buildings. Often garish and overproduced, they have something of the Ghost Train about them, which adds to their appeal. Like the carnival owner turning McCurdy into a ghoul, they recycle the past – most of them feature local history displays and decor that references their location and backstory. Commercially, they are a huge success, able to make £36m profit during a recession (BBC, 2014).

In a strange way I feel that I *personally conjured them into being.* As a young man with a passion for pubs and ale I looked at normal boring buildings such as telephone exchanges, carpet shops and old theatres and thought that they would be much better turned into bars, with long rows of real ale pumps. Bars that are open *all the time.* And wouldn't it be great if they also provided cheap cooked breakfasts and curries... I subconsciously formulated these desires into an act of magickal will and now here they are.

And another thing. Have you noticed how imaginary world fantasy has become such a massive thing? How the genre of *Lord of the Rings* and *Game of Thrones* is such a huge presence in bookshops, cinemas, television; not to mention games, conventions, cultural references; even tourism, with trips to locations and studios becoming a popular pastime? *That was me too.* In my fevered adolescence, fantasy stories were a scarce commodity. No-one had written anything like that since Tolkien, and the only books available were paperback reissues of 19th- and 20th-century works, mainly imported editions in the Ballantine Adult Fantasy series. Together with allies Gavin, Glenn and Huw, I scoured every possible outlet for such books, making long quests through Brighton's backstreets in search of *The Wood Beyond the World, The Night Land, Lud-in-the-Mist* and *The Cream of the Jest.* It was hard work, the victories were few and the texts themselves sometimes unrewarding. Every fibre of my inner being yearned for more, for vast adventurous worlds, to be able to freely inhabit a certain kind of magical space – and now, like manifest desires of a victorious magician-king, artefacts of fantasy are everywhere.

Other things have made way for the transformations I requested from reality. Back in the days when elves and unicorns were hard to find, WHSmith's used to have shelves for 'Romance', 'Adventure', 'War', 'Westerns'. These genres have now more or less disappeared – except as categories for electronic books, and in public libraries, where unalphabetised shelves of Mills and Boons and cowboy books can still be found, adorned with cryptic marks made in them by their most frequent readers to recall which ones they have read. The geography of imagination has changed. It has changed physically – for instance, Westerns used to be on sale in newsagents, garages and bookshops, but are now sold so rarely that the arrival of some in a charity shop is an event worthy of a notice in the window. It has also changed mythogeographically, the worlds of fantasy fiction becoming popular concepts, shared worlds that millions can walk into, with access points everywhere.

OK, perhaps I didn't personally conjure these phenomena into being. Perhaps, as a privileged child of the baby boom, living in the west (as in the western world, not the Wild West or Tolkien's western lands) it just seems as if things go my way. Born at the tail-end of postwar austerity, I have lived through scarcity transforming to surplus, which (at least in the worlds of entertainment and diversions) comes as a deluge of superabundance that, flowing into every nook and cranny, creates the illusion of individual preferences being satisfied. The consumer reality gives consumers what they think they want; products multiply until even the most obscure wish seems satisfied.

The Queen's Picture House in Waterloo (Merseyside) showed its last film in 1959: 'Buchanan Rides Alone', a Western starring Randolph Scott. In 2012 the building reopened as a Wetherspoon's pub. I had a coffee there at the start of a walk, rather than a pint, despite the range of craft beers from microbreweries on offer. My biochemical preferences had changed – I had chosen to no longer be the drinker. I too 'was one thing', but am now 'another'.

Walker's Role

The Slow-Change Viewer

Quick-Change Artists change outfits and appearances in seconds – a shimmer of the curtain and gosh-wow, a new costume. Performer Leopoldo Fregoli (1867-1936) was reportedly able to appear as 60 characters during one show. Slow-Change Viewers operate at the other end of the spectrum, noting the shifts of years and decades, the changes that are so slow that no-one notices they have happened.

The Slow-Change Viewer walks, aware of transformations, observing how elements of the environment have been repurposed, overwritten, functionally altered over time. By walking the territory, the Slow-Change Viewer gains understanding of changes of use, who they benefit and how they work. They can see how their own roles in the world (consciously-played or not) are part of the cause of the changes they see around them, beneficial or otherwise. They can see how they themselves are changed. And begin to glimpse ways to create new transformations...

Jump Over the Back Fence

Walk in places you have known for a long time. Look up. Look around. Walk new routes to see familiar places from fresh angles. Note in particular anything that 'was one thing, but is now another'. What has been changed and by what agency? The seasons, human forces, you? Extrapolate a future when your dearest wants have transformed the landscape.

Four: The Summoning and Banishment of a Spirit

Legend:

Pecten – any occult symbol or practice co-opted by business or state.

– *Mythogeography* (2010: 12)

2015

I remember Brighton's Churchill Square, as it was conjured into being in the late '60s. I never knew the streets and buildings it replaced – the entities that were banished. Old maps show pubs, a Mission Hall, a meat market. My early memories are of the multi-level shopping centre invoked in their place, a place of modernity. Shops surrounded a square, there was a vast car park and the GPO (later British Telecom) occupied an office block with dark blue walls. The various elements were stacked in a blocky, rectilinear way. In its heyday, it was a thriving retail space, national chains such as Tesco, WHSmith, British Home Stores and HMV trading there vigorously. There was a Habitat, with its novel continental quilts and furniture that was made of straight lines, like the surrounding science-fiction buildings.

In the central square, open to the sky, was a large sculpture rising from a pool of water. Broadly rectangular, it was an assemblage of differing textures, organic shapes fused into cuboid concrete forms. In our family this was affectionately known as 'The Monstrosity', as in 'meet by the Monstrosity at three o'clock'. I have a memory of my Nan muttering darkly that it had been made by 'people from the University', which in those days meant Sussex University, first of the postwar Utopian campuses, appearing on nearby downland during the 1960s, a logical base for dubiously radical artists to be found.

The sculpture, by William Mitchell, was actually called 'The Spirit of Brighton'. According to *Public Sculptures of Sussex*, it "was sand-blasted and included sculpted rockery with tumbling water features. It was also originally to be laquered (sic), including pieces of gold mosaic meant to catch the sun. There were shrubs around the base and the sculpture was floodlit."

The sculpture is not always fondly remembered: "The whole site was filled with forbidding slabs of concrete typified by an ugly sculpture called

the Spirit of Brighton" (Trimingham, 2001); "It epitomises the dreadful concrete redevelopment of Brighton in the 1960s and '70s" (*My Brighton and Hove*, 2007); "Churchill Square also sported a large, ugly, jagged piece of sculpture (concrete, of course) called for some reason The Spirit of Brighton" (Arscott, 2009: 166).

The concrete nature of the sculpture is a key ingredient in this remembered offensiveness, as if the material itself was some form of undesirable substance irrupting into the town under the direction of malign creators. If one wished to find a High Priest of Concrete, Mitchell would be a good candidate – a pioneer of decorative uses of new construction materials, in the '60s he gave lectures on behalf of the Cement and Concrete Association, and made sculptures for the grounds of their headquarters – "The Corn King and the Spring Queen – fertility ceremony in concrete. Listed Grade II by English Heritage" (Mitchell, 2014: 107).

When Churchill Square was redeveloped in the 1990s, the Spirit of Brighton was demolished and allegedly "became hardcore in the new building site" (Ewing et al., 2010: 70) – effective and utter banishment, as complete as that of any supernatural entity erased within a pentangle. I decided to make a pilgrimage to the site, to see if any traces of the Spirit still existed.

I set off towards Churchill Square at the beginning of May, which happened to be the start of the Brighton Festival. Normally the LED bus-stops announce the real-time arrivals of the next buses, but today this information was suspended "Due to the Children's Parade", a disruption to normality licensed by "Festival". (At the first Brighton Festival, a pre-Spirit Mitchell had been involved in dying the sea red, to evoke Homer's "wine dark sea").

The timetable-free bus eventually arrived and I made the familiar journey to Churchill Square. Time, for me, was constrained on this occasion – this was one of a series of 36-hour flying visits that I was making to my elderly parents, attempting in the process to make a better job of being a son. As a consequence, a leisurely ramble three miles into town wasn't on the cards. These days, for me, mythogeography was a hit-and-run affair.

Getting off the bus, I crossed the road to what to me was the 'new' Churchill Square. Although 'The Spirit of Brighton' was not (I assumed) going to be there, I did see sculptures – two granite-flanged shapes on plinths. I walked up to the nearest one and stood in one of its angled spaces.

The word MAY, the current month, was etched into the surface along with lines that looked like weather and music.

Stepping away from the art, I headed into WHSmith's, the stationers and bookshop, which seemed to occupy the same space it always had, even though the Centre's design had been radically changed. Inside, stairs and escalators appeared roughly as I remembered them. The magazines and books were different but the underlying structure appeared the same. This was still the holy ground where I had discovered all kinds of strange literature, teenage hands grabbing copies of *Nova Express, Illuminatus!* and Mick Farren's *Texts of Festival*. Descending one level and exiting through the back of the shop took me inside Churchill Square, now an enclosed space under a glazed roof. Turning left, I used dead reckoning to walk towards where I remembered 'The Spirit of Brighton' to be. This took me into a brightly lit lingerie area in the British Home Stores department store. My internal compass said this was the approximate location – though there were still levels below to explore. If, as had been written, the sculpture had been 'demolished' and used as hardcore (a workaday version of Puritan iconoclasts destroying 'superstitious' imagery in churches, and Islamic State 'cultural cleansing' of museums and libraries), it was presumably in the foundations. I took the stairs down to the basement level, which was mainly car park, the floor shiny and dark, 'fair-faced' concrete designed to absorb the vibration of thousands of vehicles.

I stood amongst the cars, imagining fragments of 'The Spirit of Brighton' suspended below. There was a photo booth; I contemplated taking a picture of myself holding up an image of the sculpture on my phone, but I would have needed some coins to do this. I headed back up to the higher, brighter levels.

I bought a coffee in a branch of Costa, a transaction which still failed to yield the necessary coins. I drank it sitting in the window, which faced out on to the Central Mall. From where I sat I could see two layers of shops, a space super-dense with logos and brands. The walkway sloped upwards towards the first-floor entrance of a Debenhams store, which dominated the end of the longest of the 'malls' comprising the Centre. Above the doors, a large digital photograph of a woman in a blue dress, reclining in a softly-focused space with pale furnishings, rose above the arcade. Perhaps this huge goddess-like figure, staring down at shoppers, was the current Spirit of Brighton, if only in ephemeral digitised form. It was a reasonable hypothesis; she was flanked with soft-focus spiky plants, dimly echoing the planting around Mitchell's sculpture.

It occurred to me that I should check out the 'centre' of the Centre, see if there was any kind of confluence designed into the structure, a space that functioned like the original site of the Spirit. I conjured a map onto my phone using the Churchill Square wi-fi hotspot, itself a spiritous entity. On the map the various Malls met at an ovoid space, with a 'Customer Service' legend and the 'i' for information symbol. Logically this would be the site for the chief spirit and genius loci of the place. I wandered along to it – an atrium stretching from the ground floor to the roof, where a substantial X of crossbeams held up a domed skylight.

I was on the upper level, which is where the customer information desk was. I retrieved the 'Spirit of Brighton' image on my phone and approached the information lady.

> 'This is Churchill Square, yes?'
> 'Yes it is!'
> 'Is this sculpture here somewhere?'
> '...No.'
> [Looks at phone] 'Er – it says it's in Churchill Square...?'
> 'What is your question exactly?'
> 'I was just wondering if it was still here?'
> 'This centre opened in 1996, which was before my time. Whatever was here before that – you'd have to try the library.'

Efficiently dispatched, I made my way out of the Centre. The bottom of the Spirit-space was occupied with a sound system and some kind of charity display. Standing surrounded by a swirl of symbols, I glanced up at the sky-X at the top of the massive column of space. A couple walked past, stopped and started kissing. I got out of there.

The next day I started my journey home, getting the train to London. I knew of another William Mitchell site, and decided to visit it on my way to a rendezvous with Jennie at Friends House near Euston, where she had been attending a Quakers' Yearly Meeting. From Victoria Station I headed off into Belgravia, the cream-coloured terraces gleaming in the spring sunshine. In Eaton Place I passed a significant intersection – the house where long-running TV drama 'Upstairs, Downstairs' occurred; 65 in the real world, 165 in the fictional world. In the biographical work *The Private Life of Dr Watson*, Michael Hardwick revealed that Sherlock Holmes's colleague was related to Angus Hudson, the butler in 'Upstairs, Downstairs'; a link to this house. As Holmes and Watson have themselves encountered a vast array of fictional

characters (Doctor Who, Dracula and Batman to name just three)[4], the address is a portal to huge numbers of possible fictional worlds.

I walked on towards Knightsbridge. In Lowndes Street, passing a round building, I had a sudden sense of being in a film. Perhaps my TV Eye (the suburbanite's most vital chakra) had been opened when I stood in proximity to the 'Upstairs, Downstairs' house. I thought I was in one of the street scenes from 'Brief Encounter', but Google told me I was most likely seeing a moment from 'The Servant': James Fox putting Wendy Craig into a taxi.

In Sloane Street the shops – Prada, Chanel, Versace – began to make me feel shabby and underfunded. These weren't just shops selling products with these iconic names, they were shops actually run by the international superbrands. I was a long way from Peacocks in Portslade, where I had bought a £10 jumper, or even the Debenhams and BHS of Churchill Square. The stores seemed to glower at the street, the windows like slots on bunkers. I was at some kind of semiotic epicentre of capital, feeling genetically, financially and socially challenged.

Walking on, my destination rose into view – Harrods, "the world's most famous department store", a 5-acre block of high-end retail. Between 1985 and 2010, the store was owned by the Al-Fayed family. In 1986, William Mitchell became 'director of visual design', working directly for Mohamed Al-Fayed: "Our collaboration harked back to the patron and artist relationship of the Renaissance – he was a Medici to his fingertips" (Mitchell, 2013: 241). Later, as "artistic adviser to the Chairman" (ibid.) Mitchell was responsible for the look of several renovation projects, including the object I had come to see: the Egyptian Escalator.

I found the Escalator easily enough by hiking through a few rooms, passing through brightly-lit spaces with the shiny fixtures and alluring perfumes of any department store, above-average staffing levels giving a sense of ready access to service-assistance. Like any tourist I gawped at the opulence of the Escalator, built in a seven-storey space once occupied by the store's central elevator system.

> My design encompassed the four vertical walls over six
> floors, plus a highly decorated ceiling, columns, a basement
> area, and a pedestrian staircase with painted walls, display

[4] Readers interested in the interactions of fictional characters are referred to Win Scott Eckert's *Crossovers: A Secret Chronology of the World*.

cases and decorative plasterwork. Each floor was to have a
series of balconies overlooking the escalator hall, comprising
of the original elevator door openings and giving customers
using the escalator a view of the merchandise being sold on
the various floors (ibid: 259).

This area is also reported to contain memorials to Princess Diana and Dodi
Al-Fayed, with a sculpture and a sort of reliquary containing photographs
and a wineglass smeared with lipstick.

I moved upwards from floor to floor on the escalators, each of which was
guarded by bollards to prevent the use of prams and pushchairs, and lined
with balustrades of bronze cobras. Gods, goddesses and pharaohs stared
sightlessly into the staircase void. LED screens promoting products were
framed by exquisitely-crafted Egyptian forms. With soft music playing and
gorgeous perfumes scenting the air, drifting upwards towards the ceiling –
"a night sky depicting the goddesses of the Egyptian pantheon wheeling
across its limitless space" (ibid: 269) – it felt like a gentle ascent into the
afterlife.

Dominating the top balcony, surveying the shoppers from the equivalent
position to the Debenhams' blue-dress woman in Churchill Square, was a
large sphinx. Amusingly, monstrously, its Pharaoh face was that of
Mohamed Al-Fayed himself, "ruler of the kingdom of Harrods" (ibid: 269).
However the store was now owned by the State of Qatar, subject of
controversy for its pharaoh-like use of forced labour to build the
infrastructure for the 2022 World Cup.

Feeling overwhelmed by the experience of being inside Mitchell's
masterpiece, I descended a couple of levels and wandered off into the store.
After a few turns I found myself in the book department, navigating blindly
through shelves of familiar-looking bestsellers. Anomalously, here in one of
the most famous and luxurious stores in the world, the book shop was
'provided' by WHSmith, the workaday chain whose Brighton branch had
'provided' the literary diversions of my childhood. I walked on – past a
section of products and information about Qatari culture, into a toyshop.
An assistant was making a miniature drone buzz through the air. Here the
background music was an actual song, with discernible lyrics – The
Beautiful South, singing "The flowers smell sweeter, the closer you are to
the grave" – another of many indicators that this place was an elaborate
tomb, filled with grave-goods.

Leaving the gorgeous netherworld, I walked out into the sunny spring-time street. Checking my phone, I read the day's headlines. Princess Diana was being partially resurrected, in the form of a middle name for a new Royal baby. An election, mere days in the future, offered a mixture of hope and uncertainty. In the song and year 1977, The Clash had prophesied "Sten guns in Knightsbridge", but it hadn't come to that yet. If it ever did, would the Harrods pharaohs topple? Unlike 'The Spirit of Brighton', demolished as merely a piece of structure, the Harrods sculptural spirit-world seemed set to endure, warded around with the charms and protective spells of wealth and English Heritage listing. And, as if by way of a final protection, carved words from Shelley gave the whole enterprise eternal irony:

My name is Ozymandias, King of Kings:

Look on my works, ye Mighty, and despair!

Back home, I rewatched 'The Servant'. I remembered vaguely that it involved role-reversal across class lines, as manservant Hugo (Dirk Bogarde) comes to dominate aristocrat Tony (James Fox). On a second viewing this seemed to be just one relationship in a network of power, control and cupidity played out amongst the characters, often shown distorted through glass or reflected in mirrors. Tony's girlfriend Susan (Wendy Craig) is a central figure, object of desire and beholder at the centre of the unfolding of the hollow, enervated drama; embracing the Servant then slapping him in a moment of mutual defeated shame, leaving as he holds the door open for her. Wendy Craig walking away from the brittle orgy scene that ends the film, and becoming a sort of benign matriarch across decades of television: the mother in 'Not In Front of the Children', '...And Mother Makes Three', '...And Mother Makes Five'; 'The Nanny'; the Matron in 'The Royal'. In 1993, appearing in 'Brighton Belles', a British remake of US sitcom 'The Golden Girls', taken off the air after 11 episodes, leaving some filmed material unshown, allegedly due to catastrophically poor ratings. Low viewing figures may well have been the reason, or perhaps the mask slipped and 'Susan' reappeared channelling her performance in 'The Servant', unleashing a maze of mirrors into the seaside comedy world, making it into something that could not safely be seen. And, in an unscreened location scene in Churchill Square, for a split second her gaze falls on 'The Spirit of Brighton', the Sphinx beholding the Monstrosity.

Landscape Feature

Like occultists, organisations practice invocation and banishment. Exploring the fate of the ritually banished Spirit of Brighton involved walking through a corporate kaleidoscope of such symbols.

Walking with awareness creates an openness to symbols of all kinds. Some come by chance: the Three of Hearts playing card I found on a journey around the Wirral coast – seemingly random, in that the backstory is invisible, such objects are nevertheless freighted with meaning. Some have been made deliberately: swastika graffiti on a bridge on the Trent and Mersey Canal – crudely sprayed and the wrong way round for a Nazi symbol, becoming a blessing for travellers. Some can be seen from the air or on maps: the mandala design of Southport Pontins. The names of buildings often make direct appeal to the godsphere, e.g. Mercury Court, part of the former Liverpool Exchange Railway Station, a stone-built temple to the god of communication, the rear of the building fed by disused viaducts. Some are in plain sight, others are hidden: faded image of a B-17 bomber decorated with cartoon caveman Alley Oop flying a purple pterodactyl whilst hurling a bomb, found in a ring binder of local history information in Northend chapel, near the M40; the image surrounded with information lying there to be read in the cool shade, the plane crashing in a nearby field, 10 crew dead in a conflagration with its cargo of 42 oil-and-rubber filled incendiary bombs destined for Bremen. Did the bombs not reaching their target enable others to live, to have descendants who live in a present where the *Alley Oop* comic strip is still syndicated in newspapers?

Many symbols that populate the public realm through which we walk have been crafted by corporations, launched into the world, spreading and evolving with an uncanny power: golden arches stalking the land like Martian tripods; signatures from Walt Disney's cryogenically-frozen hand binding retail spaces to his Magic Kingdom. Some have overt mythical origins – the double-tailed Starbucks mermaid making a silent siren lure into spaces where, in their words, 'Geography is a Flavour'.

Do robed kabbalists forge these symbols in secret corporate scriptoria? Possibly not, but the use of images to bring about desired results, the appeals to the mythosphere and the symbolic demarcation of territory draw on a magick repertoire.

Walker's Role

The Metaphysician

If our environment is seeded with occult symbols deployed 'by business or state', then having a role in our repertoire that can identify, decode and neutralise the effects of such symbols is clearly useful. Let us look towards a person who:

> knows what he is talking about better than any one else. He is a philosopher and a **metaphysician**, and one of the most advanced scientists of his day, and he has, I believe, an absolutely open mind. This, with an iron nerve, a temper of the ice-brook, and indomitable resolution, self-command, and toleration exalted from virtues to blessings, and the kindliest and truest heart that beats,

someone whose "views are as wide as his all-embracing sympathy" – Dr Abraham Van Helsing (Stoker, 1897/2012: 165, emphasis added). As a "metaphysician", Van Helsing can see structures, causes and principles in operation, enabling him to help overcome even the mutable and relentless Count Dracula, who intends to use occult practice to "create a new and ever-widening circle of semi-demons" and, like an amoral business or corrupt state, "batten on the helpless" amongst us, the "teeming millions" (ibid: 83).

It is worth noting that fighting Dracula is very much a team effort; the Metaphysician is no lone genius. It takes a motley crew of characters to do the job, and not just a gang of blokes – Mina Harker, an "angelic" dutiful wife with the independence of a New turn-of-the-century Woman, is "the train fiend" who memorises whole timetables, a pre-internet collager of information and communication, who almost becomes a vampire herself and sees Dracula from the inside, as well as wielding the ultimate power: editing together the very text within which she exists.

Jump Over the Back Fence

Walk assuming all signs, logos, man-made shapes and insignia have hidden meaning and arcane purpose, observing any effect they have on you. Devise your own meanings for them; use them as the basis for your own mythology, which can last as long as you wish. Notice the deeper strata of symbolism, beneath the surface dusting of logos and signs: shapes of buildings, alignment of streets, unvoiced commands, poetics of skylines and faint melodies.

Five: Novel Ideas for Great Days Out

Legend

Plaque Tournante – a junction where decisions change everything, a place of will alone.

– Mythogeography (2010: 12)

2008

Chester seemed dense, as if from accumulated layers of time, still feeling like a Roman city ("the Empire never ended" as Philip K. Dick pointed out in *Valis*), despite the chain stores and free wi-fi on the Via Principalis. At the Amphitheatre, the 'Gladiator Tour' was advertised by a life-sized image of a fighting man covered in, but not particularly bothered by, many blood-dripping wounds. Outside a supermarket, a poster said 'Life flows better with Visa', a piece of branding seeking to work at an ontological level, reminding me of a flyer for a talk about 'Surrendering to the flow' in a handout from the Chester Theosophical Society I had glimpsed on a rack outside a shop in the 700-year-old Rows, a first-storey gallery of shops. In a motel I read the room's corporate free magazine, *At Your Leisure*. This offered a copywriter's view of Britain, divided into tourist zones where "whichever attraction you choose" was always close to a motel. Written for people in the position of entertaining children as well as themselves, it was full of hyped up, accelerated statements: "For the ultimate North West experience check out some of these great attractions: Belle Vue Greyhound Stadium..." In the magazine's view of the world, the North West is a place to "Do something different", whereas the Midlands promises "Novel ideas for great days out", ('novel' referencing the literary connections, "the fascinating worlds of Robin Hood and William Shakespeare, Ivanhoe and D.H. Lawrence"). There was an invitation to "walk back through fossilised time..."

As I ate breakfast in the food/pub place adjoining the motel, I looked at the motley walls of reclaimed brick. Traces of paint and staining indicated that they came from many different buildings. I wondered idly if events of the past might be imprinted on objects in the environment, as suggested in

numerous ghost stories. If so, what happens to the ghost-traces when the bricks are dispersed – the outhouse wall that witnessed a fevered betrayal now divided between several new-build replicas of converted barns, strategically-sited copies of olde worlde pubs and commuter-belt garden walls? Is the recorded experience replicated in all of them? Does each new construction become a massive cut-up text of hauntings, or do they all blend into a supernatural emulsion? If ghostly consciousnesses lingered in the motel food-pub, they would have endless music to enjoy, bear witness to countless wi-fi breakfast emails, alcoholic afternoon chasers, and the slow settling of dust on dried flowers.

From Chester I walked to a crossroads hamlet called Broxton, where I stayed at an inn. The next day I set off too early for breakfast, so leaving the inn meant picking my way across a route marked out in the bar to avoid alarmed areas. I had a long day travelling into Shropshire planned, aiming to finish up at Whitchurch. This was a slog on a wet day, much of it walking on grass verges watched by disinterested cattle. I got turned around on Bickerton Hill where sandy paths descended in various directions that seemed at odds with my map. Skirting a field containing a bull added an extra mile. Hungry, I saw a pub ahead at a roundabout junction – but it was closed, with trees growing through its roof. I was glad to get to the station and conclude that leg of the walk.

Nevertheless, I was looking forward to rediscovering Shropshire, planning satisfying hill-claiming routes to get from Whitchurch to Wolverhampton. To add to the rediscovery of past joys, Jennie and I planned a weekend's camping near Whitchurch. Using a tent as a base, I could walk while Jennie went sightseeing. I found a promising-sounding campsite on a tourism web page and made the arrangements by telephone. It was a normal conversation with a few non sequiturs that I put down to my having been out of the camping game for a while – something about their not offering 'hubcaps'.

We travelled down after work on a Friday in May, driving to the location given on the website, discussed on the phone and confirmed on Google maps and… nothing. The farm existed, with the right name, but there was no sign of a campsite and no people around. I heard the laughter of children, but saw no other evidence of human beings. I was convinced that I had made no error, so what might the reason have been? Perhaps the campsite had closed long ago, and I had been speaking to someone with dementia. Or else the phone line had patched through to the past, and I had been talking to a deceased person.

Shropshire had its share of strange tales. Those documented by Charlotte Sophia Burne in *Shropshire Folk-Lore: A Sheaf of Gleanings* suggest that the uncanny may be hard to avoid in these parts – a gentleman once saw a huge funeral procession, rushing through "the hollow of the road" on the Long Mynd, "fast as fast", and the thought-forms of animals, such as "the know of a dog... the shape of a dog when the dog isn't there" seen by a young girl in her yard, roam the villages. "Theers al'ay summat to be sid about theer", Shropshire dialect in Burne's book resembling that of H.P. Lovecraft's Vermont backwoods: *The Dunwich Horror* replaying in an SY postcode.

I looked around in the springtime dusk, deciding where to walk next.

Landscape Feature

I had stumbled onto a 'Plaque Tournante', a hub where decisions flowed effortlessly. Standing in an empty farmyard being laughed at by ghost-children, I had to move and any option would work, though on a rational level none seemed particularly appealing. Give up? Sleep in the car? Find a motel?

Based on gut feeling I decided to abandon Shropshire. It was just too uncanny. I could tolerate the weirdness of my own county; proper Sussex weirdness – farisees living under grassy tumps, knuckers steaming in their holes and the Long Man holding open a gateway to beyond. (For details I recommend *Sussex Folk Tales* [O'Leary, 2013]). But disappearing campsites and phantom children were too much. So we went home and I restarted the walk from the last homely place I could remember: an Ice Cream Farm in Cheshire.

Things I saw as a result of this choice:

- graffiti beneath a canal bridge saying WHIT POWER

- a shop next to a remote roundabout festooned with a vast profusion of signs – the building almost hidden beneath scores of notices ranging from professionally-made lists of products to laser-printed A4 sheets pinned to bags of logs and potatoes, the fading ink spreading within the encapsulation

- luxuriant dusty outgrowths of bushes and shrubs emerging from stained concrete blocks edging indeterminate structures: abandoned car parks or possibly empty flats

- a skinny guy on a canal boat sporting a magnificent tattoo of Conan the Barbarian, based if I wasn't mistaken on a John Buscema drawing from the 1970s Marvel Comics' version of the character

- a sinister picture of a dog-like creature, sunk beneath the River Sow, still in a gilt frame, the image malformed by black mould.

The planned Shropshire route remained forever unwalked; rather than a site of exploration, the county had been a place of passing through. I could have spotted the signs earlier: the accommodation at a crossroads, a mirage pub at a junction, lostness... Earlier still, from the mid-Sixties I had been seeing subliminal clues: the soap opera 'Crossroads' was set in a fictional Birmingham location but featured several locations actually filmed in Shropshire, including the exterior shots of the Crossroads Motel itself, appearing daily in the credits. Teatime TV had primed me for this kind of borderland.

Walker's Role

The Junctioneer

Blues singer Robert Johnson "went down to the crossroad", the place where it is impossible to "flag a ride" and even nature seems out of sync, or weirdly speeded up: "risin' sun goin' down". Crossroads have been mythologised as sites for encounters with the divine and supernatural, liminal places. The Junctioneer is the walker who seeks out places where choices have to be made, lives out the choices (as a form of play) and moves on.

Jump Over the Back Fence

Walk the junctions of this world by following your instinct, centring yourself at each point of choice to see where you *really* want to go. Or devise a randomised way of making choices at every junction you encounter. (A detailed example is included as Appendix Two). Notice how each choice you make brings into being a new world.

Six: Touring the Six Realms

Legend

Pylon – a trajectory of ideas or commodities.
— *Mythogeography* (2010: 12)

2010-2012

Recovering from my operation, trying to re-orient myself in a life that felt shorter and more mortal, I delved into books about spirituality. Although these came from many traditions, meditation always seemed to appear as the punchline. This annoyed me as I assumed, based on experience, that meditation was something I couldn't do. Either I would fall asleep, or start thinking about work or some plan I was making. It felt like a dirty trick; there were all these books, with titles and blurbs implying they contained 'the answer', which always turned out to be meditating, something beyond me. However, having reached a this-is-it, balls-to-the-wall stage of life (that didn't feel like being alive in the same way it used to), I was seeking for some way to deal with reality and the ultimate horizon. Clearly just reading books wasn't going to cut it, and whatever this walking journey was, it was only an occasional pastime, so adopting a regular spiritual practice felt like a useful step to take.

I had come across a teacher called Alan Chapman, whose approach to such things seemed down-to-earth and devoid of dogma, and decided to contact him about the possibility of lessons. On Skype he seemed eminently normal, a young guy in an Abercrombie & Fitch hoodie in what looked like a bedroom with some weights and storage boxes in the background (rather than, say, a bearded guru in an ashram equipped with a fleet of Rolls Royces, being serviced by brainwashed acolytes). We chatted for a while. I was slightly surprised by how matter of fact Alan was about 'enlightenment' as a natural and achievable phenomenon. He didn't seem to be talking about an esoteric state or anything supernatural, more like an alignment of consciousness with reality. I took the plunge and committed to following his suggested programme of 30-minute daily meditation sits.

Feeling less alienated from spiritual endeavours, I looked once more into books and websites, where I came across the Buddhist concept of the Six Realms. Depending on what one read, these were mystical states, psychological states or actual physical places: Animal Realm, Human Realm, Realms of Jealous Gods, Hungry Ghosts and Gods, and the Hell Realm. The Realms were often depicted in a mandala, a circular picture with six quadrants, rather like the Trivial Pursuit 'cheese' with the six wedges. It occurred to me that superimposing the mandala shape on a map would create six areas containing territory that could actually be visited. The centre point of the country seemed like a good place to make the centre of the mandala. This necessitated a choice, as there are several, depending on whether the country used is England, the United Kingdom or Great Britain; whether islands are included; the effects of coastal erosion and so on. I decided on Meriden near Coventry, the 'traditional' centre of England.

The psychogeographical technique to be used was the 'Finding' approach given by Duncan Barford in his blog post 'Inside the Entrances to Hell': "decide beforehand the outcome of the journey, and then look to experiences during the journey as the provision of that outcome". Perhaps externalising my meditation practice into physical territory would yield interesting results.

I set off on the Saturday after the opening ceremony of the London 2012 Olympics, a vast and emotive spectacle that had come as another chapter in what seemed like an unending sequence of state-sanctioned celebrations. Earlier that year the Queen's Jubilee had seemed vulgar and intrusive – though having lived half a century as a 'New Elizabethan' I felt entitled to some kind of celebration, and had bought a spiffy pair of black Union flag cufflinks to wear to a function which featured a monarch impersonator whose act had to be curtailed due to rising levels of audience conversation.

As for the Olympics, I shared the alarm felt by many at the tinpot-dictatorhood surrounding the event; the expense incurred at a time when public spending was being cut and daily life seemed to be deteriorating, fear blooming in the corners. Although I hadn't seen the opening ceremony, I had experienced it at a distance online and, even through the filter of other people's descriptions, had been moved by it. Fervour and despair mingled in my veins like strong wines.

I caught my first train in the late morning. The weather was cycling through various modes, by turns hot, cool, wet and dry. It was good to be cutting loose, making some kind of pilgrimage again after several months without a walking trip.

And yet I felt cumbered with stuff, two bags hanging on me like panniers on a donkey. Whereas Ishmael would stuff 'a shirt or two' in carpet-bag and go to sea, for my three-day trip I had about my person:

- ❖ Digital map centred on Meriden, the 'traditional centre of England' (print-on-demand from Ordnance Survey)
- ❖ Walking shoes (North Face 'Hedgehog')
- ❖ Box of pills (x6 varieties: made by companies called Sandoz (two kinds), Consilient, Teva (two kinds), Actavis; box made by Muji)
- ❖ Camera (Panasonic Lumix)
- ❖ iPhone (Apple)
- ❖ Charger and lead (charger no-brand, lead Apple)
- ❖ Watch (Casio-416, beloved of hipsters and millions wanting a cheap watch; sometimes referred to as the 'Guantanamo watch' from its association with use as a cheap source of bomb components and therefore as evidence for detainment)
- ❖ Ballpoint pen (Bic)
- ❖ Pencil (Paper ♥ Mate)
- ❖ Pencil (Staedtler)
- ❖ Notebook (Moleskine)
- ❖ Book: *Transcending Madness: The Experience of the Six Bardos* by Chögyam Trungpa
- ❖ Book: *Wake Up to Your Life* by Ken McLeod
- ❖ Comic: *Commando* 4518, 'Stay on target!' by Allan Chalmers, Keith Shone, Ian Kennedy
- ❖ Jacket (Baracuta Harrington G9 'natural' colour)
- ❖ Polo shirts (Fred Perry and Baracuta)
- ❖ Jeans (M&S)
- ❖ Underwear (M&S)
- ❖ Socks (Hi-Tec)
- ❖ Showerproof coat (Patagonia)
- ❖ Spectacles (Specsavers 'Osiris' brand)
- ❖ Toothpaste (Colgate)

- ❖ Toothbrush (Boots)
- ❖ Messenger Bag (Eastpak)
- ❖ Man-bag (Eagle Creek)
- ❖ Wallet (Jack Wolfskin)
- ❖ Cards entitling me to travel, giving access to money or credit/debt
- ❖ Cash (Bank of England)
- ❖ Train tickets (Virgin)

as well as some built-in items:

- ❖ Tattoo ink suspended in my arm
- ❖ Chest-bone wires
- ❖ Fillings.

So I was a mobile congeries of stuff created by various entities, bearing many names, that had been assembled in many places – China, Vietnam, India, USA, UK – from materials that in turn came from many other places. 'I' was a temporary focal point, perspiring with the weight of it all. It would be nice to travel around like thriller character Jack Reacher, carrying only a toothbrush and throwing clothes away instead of washing them. But most of my stuff felt essential, even the mobile library.

North of Liverpool, the train passed the remains of the Paradox, once a nightclub in a former Vernons Pools building – now a square ruined tower with stopped clocks facing the four quarters.

I changed train at Sandhills. There was a guy with a bike, drinking a can of Special Brew, its sweetly pungent odour spreading along the platform. His face was striated with scabs, punctuated with stitches. He made several phone calls, describing an accident, how his eyebrows 'had to be superglued into place', how they would 'see the road lines' in his face.

The next train came and the journey continued, through a series of Liverpool stations. It was hot and bright, like an imaginary summer. Buddleia was in bloom, filling neglected junctures in masonry and at the edges of waste ground.

I looked at the passing landscapes, through my Osiris-lenses.

On a plant high on a bridge, a red balloon, half-deflated.

I spent the night at the Bull's Head in Meriden, which featured a brass plaque set into the parquet floor indicating that this was the centre of

England. There was also a plaque indicating the same thing on the nearby village green, by a market cross that had been relocated there as part of a programme of improvements to the green, during the Festival of Britain. I wasn't too bothered about finding the exact centre, this was 'close enough for jazz'; clearly I was in a place of centres, which was the general idea.

The inn was pleasant enough: an old coaching inn on the London to Holyhead road. I ate fish and chips, and drank Pure Ubu beer, the name invoking Alfred Jarry's absurdist hero Père Ubu and the band named after him. Flickering memory of a line from one of their songs: "My hands are complicated thoughts... But my feet just wanna go".[5]) On an evening stroll, in an antique-shop window I saw Star Wars action figures nestled with crockery that looked like vegetables with faces, and cushions with eyes.

In the morning I looked at my map, on which I had sketched outlines defining segments that would be the 'six realms' for the purposes of this experiment. A provisional itinerary involved starting off by heading west-southwest into Animal Realm, then proceeding counter-clockwise to conclude in the Human Realm. I was flexible about how far I needed to go from the centre into each Realm and was taking into account points of access to public transport. Looking at the map, there was a bland segment of territory featuring roads, footpaths, rivers, farms, a railway. In a sense it didn't matter which route I took as I had decided that whatever would be encountered would be the Realm in question – so there was no need to seek a particularly animalistic place. Nevertheless, looking at the dead straight B4102 road on the map, I was reminded of Chögyam Trungpa's description of the Animal Realm:

> The animal quality is one of purely looking directly ahead, as if we had blinkers. We look straight ahead, never looking right or left, very sincerely. We are just trying to reach the next available situation, all the time trying (1999: 261).

I could relate to this as a type of psychological habit, and also visualise an animal, or perhaps a zombie, simply taking the most direct route. Would there be a path alongside the road? If not, would traffic make it dangerous? I had no way of knowing, but decided to face any obstacles with brutish animal-style efficiency as they came up, and opted for the B4102 as the start of my tour.

[5] The song is called 'Go', on the album 'The Art of Walking' (Rough Trade, 1980).

Unseen dogs barked as I walked into Animal Realm. I took this as a good sign. There was in fact a footpath, somewhat overgrown so that branches would scrape at me as I went past, but otherwise unobstructed. I loped along, aiming to simply focus on the destination, the village of Hampton-in-Arden where I would have to change direction and decide how to travel onwards.

I noticed some things on my straight path. Several empty cans of Carling by the road, seemingly fallen at regular intervals, as if thrown from a car in a timed sequence. An invoice from Matrix Bathrooms. In a lay-by, a soft porn magazine that looked new but was in fact over ten years old.

I arrived at Hampton-in-Arden and sat for a while beside their war memorial. I had found a practice for 'Emptying the Six Realms' in Ken McLeod's book (2002: 236) and had decided to attempt it in each of the realms visited. And did so, starting in this quiet spot beneath large dark trees.

Describing what happened during a meditation session is always likely to be misleading. I am painfully aware that saying it is 'beyond language' or 'you have to experience it yourself' sounds like a cop-out or implies that gosh-wow transcendent states have happened, which the meditator is too new-age-addled, lazy or blissed out to talk about. This is one reason why having a teacher, a 'friend in awakening', is a good idea as dialogue with a live person is often more useful than words on paper. But here goes…

> I sat for a while simply paying attention to my breath – the soft feeling of the air moving in and out. Then I invited the emotions of the Animal Realm. Feelings, associated with instinctive survival and a brutal urge to simply press on, arose. Trying not to get stuck into the feelings or to elaborate on them with chains of thoughts, I contemplated what they felt like, the sensation of them in my body. Not trying to push them away or change them I just sort of noticed them for a few minutes. Then, let them go – in other words, stopped contemplating them or being concerned if they were there or not. Bringing Animal Realm back into my attention (in the form of the walk I had just finished), I "let the images fall away and subside" as instructed in the book. After that I simply sat empty and quiet, thoughts and images coming and going. Consciousness looking at itself, in an empty space that is somehow not just an image of 'empty space'. I opened my eyes and here I was again, 'I' and the place I was in, and everything else, just there.

I could have caught a train to the Hell Realm, but as the next one was not due for 45 minutes I decided to walk. Heading southeast, I crossed some fields, skirted a large body of water and got slightly lost in some marshy, tummocky ground in a nature reserve. I entered Hell, uneventfully, beside the entrance to the West Midlands Golf Club.

I moved on into Balsall Common, past a motel and into suburbia. There was no-one around, but I was naturally wary of "a world of unspeakable violence and pain" (ibid: 236). Taking the Buddhist books as guidebooks I could expect dramatic, interactive scenery: "both the sky and the air radiating red fire", with aggression spawning further aggression until "Finally there is no space; the whole space has been completely solidified, without any gaps" (Trungpa, 1999, p. 282-3). However it seemed that I was moving through open space, with no fire or demons; just a normal suburb, similar to where I grew up and where I now live – but with larger houses. So how was this hell? I could conjure up some annoyance about the houses being bigger and more expensive than mine, but that would just be acting a part. Chögyam Trungpa said that "The aggression does not seem to be your aggression, but the aggression seems to permeate the whole space around you" – so perhaps there was no need to search for angry emotions, simply look at the environment. As I passed endless houses and gardens I speculated that there was a kind of codified aggression built in to all these homes, squatting behind uPVC doors. The houses were built for defence – the front garden displays fulfilling the function of moats and killing-grounds surrounding fortresses; partly-visible front rooms proffered to the street-sides of the houses as dummy displays concealing the reality further within. And what could be more dangerous than a home? Sites of violence and the tragedies of decades held in suspension, molecules of misery settled into carpeted corners.

In a travel agent's window, a sign saying 'We Sell the World' provided a momentary glimpse of powerful, sinister forces at play here.

As I walked up towards Berkswell station, large warm drops of rain began to fall. I did the meditation sitting on the station, allowing the aggressive sensations of Hell to rise up, finding it disturbingly easy to connect with cold fury and fear. I sat contemplating as precisely and openly as possible these feelings of hatred. When I opened my eyes, people had started to arrive at the station, family groups walking across the bridge to my platform. Fresh from the walk and the meditation, I could clearly recognise my instinctive defensive reactions to these 'others', along with more acceptable thoughts and feelings such as curiosity and kinship.

I planned to take a train to Coventry. The wait was quite long, and I began to think about the next realm I would encounter, that of Hungry Ghosts – a place of endless, unsatisfied consumption and continuous grasping poverty. More people began to gather on the platform, building to a large group. Some of the Olympic games were being played in Coventry, and people were headed in to watch soccer matches. Recorded messages warning in general terms of potential delays played repeatedly. The train was a few minutes late, though as if to compensate no-one appeared at any stage to take fares.

At Coventry station we were welcomed by people in London Olympics livery, many with large foam pointing hands, and whisked along towards free buses. I considered going with the flow for as long as possible to see if I ended up in a sporting event, but decided to head for the town centre instead. Union Jack bunting had been liberally applied above the streets, and the annual Godiva Festival added to a carnival atmosphere. I headed for a Waterstones (chain) bookshop, and wandered from floor to floor, focusing on the urge to consume the thousands of books. I breathed in the smell of the paper, remembering the sight of a hippy-type guy sensuously rubbing the pages of an open hardback on his bearded face, eyes closed in ecstasy, in Brighton WHSmith's circa 1974. Rather than buy a book, I joined a long queue in the café. As on most days I had a dull, time-specific craving for a milky coffee, and I had arrived at that timeslot. Aping what I thought a Hungry Ghost would do, I ordered an over-the-top version of coffee with flavoured additives and a cream top, some 'artisan' crisps and a cupcake. I found a quiet table, ate this sickening, empty and glitter-specked lunch, did the meditation and watched the bunting hanging against the bright grey sky. It was hard to create a space for contemplation with people bustling around, alert on one level for the possibility of being knocked into or spoken to. The idea that a man sitting with eyes shut in a bookshop café would look odd and perhaps require staff intervention added to the unsettled feeling. I tried to *include* all of these perturbing sensations into the practice, realising that the desire for peaceful, proper, spiritual-feeling meditation was exactly what the Hungry Ghost in me was experiencing. Job done.

Leaving Coventry, I got a train to Bedworth, a town just south of Nuneaton. From there I planned to walk to a motel where I had booked a night's stay. The train took me into the realm of the Jealous Gods, Titans, or 'nongods', where envy, competition and paranoia permeate the landscape. The light was fading in the high street of a typical market town, devoid of quaintness. I stopped for a drink in a pub – the beer was rank, the service

unhelpful, the clientele seemingly over the horizon of drunkenness. I moved on through the town, steadily climbing a hill, stopping to buy mints at a convenience store beside a garage. A little boy wanted his mum to get him a sticker album, but she refused because you just had to carry on buying the stickers and it would be a waste of money. (Having failed to complete an Olympic sticker album in the '70s, I would have to agree). I arrived at the motel, a Premier Inn with adjoining Beefeater restaurant, which turned out to be a house where George Eliot once lived, the building and surrounding landscape the inspiration for elements of *The Mill on the Floss*; I was now in one of the texts I had passed, unknowingly, in the hungry-ghost bookshop. (I checked its availability online and the Coventry branch had copies in stock). I had a meal and sat outside for a while with a glass of wine, watching cars and lorries circling the A444 roundabout. Beyond the shrubbery I could see the shallow steel angles of the Bermuda Business Park.

In the morning I sat doing the meditation, finding it hard to focus on the concept, then set off and skirted the Bermuda Park, a lone pedestrian on a delivery road. I was on the Centenary Way, a signed long distance path that I planned to use for few miles, to travel from this Realm of the Jealous Gods into the Realm of the actual Gods. The route of the Way crossed the A444 on a weed-grown road that felt like the straggling end of roads; the place where roads gave out having done their job. Then I was on normal streets again, in a modern housing estate. I saw two figures walking towards me – a remarkably tall couple, I estimated about seven feet each. The guy had dreads, rather like Ronon Dex in 'Stargate Atlantis', while the woman was blonde and so thin she seemed elongated. Their clothes were odd, something like Goth or fetish wear but with a utilitarian, functional look, pockets and clasps configured for some unfathomable task. 'At least these look like gods, or maybe titans dressed up as gods' I thought, pleased to encounter a direct manifestation of the nature of the territory. The meditation may have felt lame but was now playing out in reality.

I found where the path left the estate for more rural parts. Passing through a gate, I saw a dark face peering at me from an upstairs window. I looked directly at the person, they looked back steadily. Then I was shielded from the gaze by bushes. I moved on from the shadow-titan in his bedroom HQ.

The morning was grey and damp. Seeing a hill beside the path, I scrambled to the top to get a better view. Looking back towards the Bermuda Business Park, I saw a huge building dominating the landscape. I later discovered that this was a Dairy Crest distribution centre, a facility dedicated to the packaging and dispatch of Cathedral City, 'the Nation's

favourite cheese'. According to the Dairy Crest Annual Report (2015), the cheese is produced in Davidstow in Cornwall which is not a city and does not have a cathedral, so this vast building was probably the most cathedral-like structure involved in the process. Although not technically a spiritual building, a kind of magic is accomplished there, the raw material of the incoming cheese rendered profitable ("Cheese profit 48%", [ibid: 2]) by the addition of signs and symbols. The cheese is a hugely popular brand, so every day there are millions consuming the 'cathedral city' meme, the name and logo hyperlinking the cheese-eaters' cortices to images mined from Barchester, Starbridge, Felpersham, Kingsbridge, Polchester; airy cities of tradition, gulls wheeling above spires, bells ringing out over centuries and aged clerics hurrying along half-timbered streets. And the meme launched here, in the centre of a landlocked Bermuda Triangle.

The Centenary Way took me through fields and around the outside of a school. It became hot. Thirsty, I hiked through an outer limb of Nuneaton so that I could get water from a shop. Then I was climbing quite steeply towards Hartshill. In the country park I would cross into the Realm of the Gods.

I sat on a bench on a hill in a light drizzle in Hartshill Hayes Country Park, for me also the edge of Deva-gati, the Realm of Devas and Heavenly Beings. This Realm sounds like the 'good' one, but these gods are deluded beings, living in bliss that is so comfortable they fail to attain enlightenment, fixated on control. They are also invisible, having evolved beyond mere corporeal form, so I did not look to the other people using the park for signs of godhood – the family group that walked past, grandchildren playing with a dog that had acquired burrs on its coat, were I thought, no more or less divine than I was. I performed the meditation, invoking the state of spiritual self-satisfaction and ecstatic bliss described in the texts, gazing into the 'magnificent view' provided by my vantage point in the park, a recipient of 'the Forestry Authority's "centre of excellence" award'. Here I was, sat in a beautiful park, immaculate, perfect – what could be better? I was, after all, meditating like a spiritual superhero. Only the itching worm-bites of mortality (those kids would be so sad when their dog died) marred the perfection. I let the illusion collapse and walked on, into the woods of Excellence, across some countryside and into Atherstone, town of the Gods. The sun was shining past black clouds. I had a suitably nectar-like pint in the Market Tavern, then got a train to head for the Human Realm.

Arriving in Liverpool, the city nearest to where I live, I wandered towards Bold Street. Though far from the centre I was still in the quadrant I had defined as being the Human Realm. I was back in familiar land, which

seemed appropriate for the Human Realm, a space that McLeod says is "about desire and the busyness that accompanies it". Here, unlike in the Realm of Hungry Ghosts, desire might temporarily be satisfied – hence the unending practical activity of everyday life. I went into Leaf, a café decorated with an artfully mismatched profusion of retro-chintz filtered through a veneer of coolness. An Instagram kind of place. It had been suggested that this type of style could be used for an exhibition stand we were planning for work, so for a while I ran the mental routines of my employment, evaluating the applicability and utility of what I was seeing for a future purpose, judging, planning, sorting. Then I came back to where I was, tasting my coffee, letting the noise of the place wash over me, watching the powdery light from the street angling into the café. Was 'work' a different realm, more or less real than the one I was in? Or just a different mental repertoire? Five days a week I walked to a particular place, the 'work-place'; moved through its spaces, talked to people, drank tea and coffee, accomplished tasks, then came home again. 'Work/Life Balance' was sometimes spoken of, suggesting that 'work' and 'life' were different, opposites even – work therefore a type of death. Was there a boundary between these states? If so it was porous, as the devices and desires of 'work' were not totally lost when I crossed the borders of 5pm finishing time and the edge of the campus.

I did the meditation and drank the coffee until only a trace of foam was left. I felt empty and light.

Meditation can sound like escapism, a way to feel better, something unrealistic, religious and inward-looking. I had not experienced it to be so: it was day-to-day life which seemed increasingly to be based on superstition and the supernatural. If we weren't recalling the past like necromancers raising the dead, we were foreseeing the future or scrying remote places, trying to imagine ways to fix things to our advantage. The rituals of work, leisure and entertainment summoned unreal entities, fantastical delusions masqueraded as mundane reality: 'Matrix Bathrooms', 'Centre of Excellence', abandoned '2012' foam-rubber fingers lying on rain-soaked embankments, 'jubilees' that neglected to free any prisoners or forgive any debts. I had made a hybrid map and walked there, trying to walk towards a freedom beyond categories.

So, the trip was done. I had been to the centre and invoked the Six Realms, walked to some places I had never been and returned, encountered pierced Titans and traversed the damp woodlands of the Gods. In the Buddhist tradition, the Human Realm offers the best possibility of liberation – every day I practised meditation, and for all I

knew the quiet catastrophe of awakening was happening in my future, as natural an occurrence as the loss of milk teeth, as a strand of hair growing out silver. The Six Realms were a map of the unawakened illusory states, a map of what-is-not; would 'awakening' be some kind of indescribable Seventh Realm?

"Liverpool is the pool of life", wrote Carl Jung, having dreamed himself into the city; "it makes to live". Now it seemed that I was here too. Leaving Leaf, I walked towards Liverpool One as afternoon light faded. Bought myself a pair of shoes.

Landscape Feature

These walks were 'trajectories of ideas' – concepts from the Buddhist canon made into walkable routes.

They were also 'trajectories of commodities' – the items I carried with me, the tourist commodities of the 'Centre of England' and 'George Eliot', the Olympics, the cheese factory and a host of other products and services. Arguably, Western Buddhism and related practices have also been commodified, marketed in books, courses and websites as packages of benefits which can be experienced by the purchaser-practitioner.

And I saw plenty of pylons. Like pylons and the power lines they carry, 'trajectories of ideas and commodities' transect the landscape. For instance, the logistics of Dairy Crest's cheese business define a sizeable chunk of Nuneaton and transport activity in and out of the massive plant I saw while walking. The successful brand-myth that is 'Cathedral City' energises the enterprise, so that much of the space, traffic and movement in and around Bermuda Business Park is shaped by an equation comprising both ideas and commodities. This may be true of any piece of territory.

Walker's Role

The Customiser

The Customiser creates new maps by adding, overlaying, combining features, then walks the hybrid territory thus created, to see what is really there.

Jump Over the Back Fence

Walk to reveal 'the trajectories of ideas and commodities' by creating impossible hybrid maps – superimpose diagrams that illustrate philosophies, theophanies, symphonies, narrative patterns, marketing plans, etc. onto cartographic maps and walk the real-world equivalent spaces, encountering the 'ideas and commodities' in actual spaces of concrete, mud and gravel.

(For example, the Ansoff Matrix, Joseph Campbell's Monomyth aka the Hero's Journey, Dante's Inferno, Kübler-Ross's stages of grief, the Tree of Life, Maslow's Hierarchy of Needs, the Temple of Solomon, Fry's Five Boys and the floorplan of the Waltons' house set – anything that has been drawn in two dimensions can (with a bit of ingenuity) be overlaid onto a map.)

Seven: Caught in the Middle of Time

Legend

Tripods – an opportunity for reverse archaeology, building the future from the ruins of the past.

– Mythogeography (2010, 12)

1988-2015

I have walked walked walked the Mersey coastline, border of my adopted home territory, the route along my horizon, down towards the lights of the city.

Looking back to plot my Merseyside journeys as a continuous route, I have hiked from Formby into Liverpool in overlapping expeditions spread over the years. My northern point is the Brick Beach at Burbo Bank – a surreal area of housebricks, parts of carved windows, lintels, concrete blocks sprouting reinforcement rods; rounded by the action of the sea, draped in seaweed; architecture become beach. Sometimes said to be a street that had succumbed to coastal erosion, it was in fact a 'revetment shore' deliberately created to protect the coastline, constructed from rubble brought up from the city over a period starting in 1942. Buildings destroyed in the Blitz made part of this beach, affecting the shape of the shoreline.

I have walked southwards through Crosby and amongst Antony Gormley's 'Iron Men' sculptures, 100 figures cast from the artist's body, dotted along a mile of beach, transforming into layers of rust. As Niall Griffiths puts it, "Their resilience stirs. They regard the sea, endlessly, and will be, in achingly slow increments, shaped and altered by it but never – or at least in no time-scale graspable by the individual human mind – defeated; they'll continue to re-appear" (2008: 52).

Beyond the Iron Men, officially called 'Another Place', much of my walking towards Liverpool has been along the A580, a road lined with the kind of businesses people drive to rather than walk to – car showrooms and carpet warehouses. Dust and litter filled the windswept angles, wild shrubbery was festooned with plastic and containers thrown from cars.

Miles of dockland transit zone, functional, built on an industrial rather than human scale, segueing into the "chain of immense fortresses" that Herman Melville described being seen by a young sailor in his 1849 novel *Redburn*.

This territory contains many buildings apparently disused, such as the vast Tobacco Warehouse, a redbrick block with countless windows, its walls always seeming to be in shade. For a long time, this to me was a picturesque ruin that I had glimpsed from the train into Liverpool (often) and walked past (a few times).

The Docks are among the many parts of Liverpool to be used as film locations. Parts of this landscape featured in the mythical spaces of Captain America and Sherlock Holmes movies, components of the patchwork construction of pop culture legends. These films also featured scenes shot at Pinewood Studios in Buckinghamshire, another place I had walked to, arriving at its high fences through dripping woods on a grey afternoon, peering through the gaps at fibre-glass boulders surrounded by weeds and wondering if they have featured in long-ago 'Earth's Core' or 'Land That Time Forgot' films. As my walks connect Liverpool and Pinewood I have (walking unknowingly through a mythical seam) made a pedestrian journey joining up the Docks with the studios, a leyline connecting two mills of the dream factory through holey time.

In Liverpool, the border into the parts of the city that have been transformed through regeneration, although unmarked with signage or lines on maps, is easy to see from a pedestrian point of view. After walking many dusty miles down from 'Another Place', I felt the moment where it all changed, with Dorothy-arrived-in-Oz suddenness. Everywhere was clean. Weedless borders had been planted with precisely-spaced flowers. Now I was in places designed for walking, on footpaths that ran beside gleaming water, banners inviting me to 'Live, Work and Play at Princes Dock'. I was feeling the "Regeneration tang/an archaeology of intent" charted by Andrew Taylor (2007) in his poem 'A Contained Rapture'. From this point the Docks are no longer sites of trade or ruin but instead become a nexus of hotels, apartments, museums, bars and restaurants, reverse archaeology revealing new trajectories of purpose, aimed at the future.

Travelling further south takes me to Albert Dock, to me the most familiar, evoking memories of walking there in 1988, from Lime Street station through the city to get to the opening of Tate Liverpool, on a jolly from the Wolverhampton museum where I worked: never been to Liverpool

before, a breathless hike through tall Victorian canyons, the idea of an art gallery in a warehouse something new and optimistic.

Now I'm arriving on a cold November evening, holding a ticket for an exhibition opening, half an hour early and wondering whether to just go home. But the doors open and I go inside, thinking at least it will be warm. There are drinks and speeches, then we are allowed into the exhibition: 'An Imagined Museum': "You've arrived at Tate Liverpool in the future. All of the works of art on display are about to disappear, forever. Which works of art do you want to know by heart, committing them to memory so that your favourite piece lives on?" In this age yet to come, museums are obsolete and art is disappearing, these few works retrieved from the storerooms of once-great galleries, offered up for viewers to remember like the works of literature in Ray Bradbury's *Fahrenheit 451*. I walk through the works, remembering art from my past with imaginary future eyes; some Andy Warhol soup cans, Bridget Riley's *Fall* rippling my eyesight, Cindy Sherman hitchhiking beside a grainy black and white road.

I go into a tiny room constructed within the larger gallery space. Now I'm in Dan Graham's *Present Continuous Past(s)*, a space walled with mirrors, framing two small video monitors. Naturally I see myself reflected in the mirrors. The monitors show an empty version of the room – but after a few seconds I am in those images as well, a past 'me', replayed via an 8-second delay: a 'me' that is some strange other guy. The catalogue, if that's what it was, a newspaper called *451 Museum: The Mnemosyne Revolution* (Garcia, 2015), annotates *Present Continuous Past(s)* from the documentation available in 2666: "References to surveillance and mirror palaces. The mirror, the double, the déjà vu, and the uncanny", going on to say that, "The Freudian concept of the uncanny describes the essence of art, as it describes the essence of dreams and the essence of psychosis: anxiety. The familiar becomes strange... what yesterday seemed so familiar and comforting and secure, is today transforming before our eyes in a hostile and unstable environment."

My friend and workmate Carl Hunter texted about a Buzzcocks' gig that was on that night, telling me I should go. This was tempting, the Buzzcocks a favourite band from my teens, Pete Shelley singing of "surfing on a wave of nostalgia/for an age yet to come" and feeling "like I'm trapped in the middle of time" – what would they sound like now that the age yet to come was actually here?

I didn't go to the gig. The age I have come to doesn't feature spur-of-the-moment late nights. I am a suburban recluse. I went home on the train. Nevertheless, nostalgic for the Buzzcocks as I remembered them, I found

the song 'Nostalgia' on my iPod – but it was the cover version by a different band, Penetration. I let their album *Moving Targets* make the soundtrack for the rest of the journey – recalling seeing them live in 1978, Pauline Murray singing the line "Do I really feel this weird sensation…?" in the Brighton New Regent, a beautiful and terrifyingly hopeful sound rising over smoke and flying spittle in the crammed, narrow venue. The New Regent was the place to see new wave bands – named for the Regent Dance Hall that had disappeared by then, a venue dating back to 1920s' dance crazes – the New Regent itself is long gone now, turned into one of the Walkabout chain of bars, where large screens show images of sunny beaches.

That night I dreamed that I was on a country ramble, when I walked into a cowshed. The floor was shiny, marble, corporate-looking with just a few scraps of straw indicating its purpose. I was surprised by this, but someone was explaining that this was how it was done now, the animals preferred it. Around the edge of the building they had built a mock-up of an older-style heritage version of a cowshed, with piles of straw behind artfully-ramshackle wooden fences. There was an old looking child sitting in the corner, mechanically reciting a poem. This child seemed somehow… *dreadful*… and I woke up, heart racing.

Landscape Feature

My perambulations on the Mersey shore have taken me over, through and into ruins, often in the process of being used to build something new. Bombed buildings used to make coastal defences, warehouses becoming galleries and apartments, empty docks as festival sites, beaches becoming sculptural installations. Capital, creativity, necessity modelling and remodelling the landscape. Hooray or boo? Is a better future being built, or are the ruins in the future? *Do I really feel this weird sensation?*

Teetering precariously over the ruins of the Brick Beach, falling or twisting an ankle was always a possibility. Sometimes the tunnels through holey time pulled me into weepy nostalgia or anxious future-scanning and disappointment. But at my best I walked the present…

Walker's Role

Present Witness

'Reverse archaeology', digging into the past to preconstruct the future, can only happen in the present. Walk as the Present Witness, to understand what is actually here now, to *move well* into what comes next.

'What is actually here now' includes ruins, beautiful, poignant decay; the past embodied, like physical memories, massive and crumbling. And beguiling: "The ruin has put on, in its catastrophic tipsy chaos, a bizarre new charm" (Macaulay, 1953: 453-4). But the Present Witness is more than a voyeur.

'What comes next' is of course the future, science fiction space filled with utopias and dystopias. But the Present Witness does more than predict idealised progress, doom or an endlessly-protracted present.

To 'build… from the ruins' (to move well) the Present Witness observes, walking around and thereby circumventing the manufactured concepts that overlay the present with redundant pasts and shaky futures.

Jump Over the Back Fence

Exorcise nostalgia: Notice when the places you are walking in evoke feelings of sentimental yearning for past, present or future. Let these feelings go. Witness what's left, however disturbing or beautiful – the real. By re-membering and sharing these landscape features, you are creating something new. Walk among current ruins to routefind a desired future.

Eight: Stardust Falling

Legend

 Benchmark – a memorial of the sound emitted at the birth of the universe (the Awen). Benchmarks in the UK indicate a sea level measured from a datum on the harbour wall at Newlyn, Cornwall.

– Mythogeography (2010, 12)

2008

I was travelling by train and then bus to Stourbridge to commence a hike into the heart of the Black Country. The news that morning included an item about the sound made by stars – some unimaginable humming in the vastness of space. Rays from our own astral body, the sun, were reaching the places I passed through on this autumn journey, as I moved on public transport from Lancashire to Wolverhampton to Wall Heath to Stourbridge. Between great gusts of wind, dislodging leaves rendered particularly colourful by the preceding wet summer, there were moments of large and curious silence. I reached Stourbridge at around 4pm and started walking, rising above the town on a cycle route. This took me past industrial units and into Withymoor Village, a residential area built on reclaimed mining land within a loop of B-road. I liked this place – winding paths, greenery, willows and leylandii – a suburb in balance, a version of the places I had always lived, approaching an ideal.

The surrounding hills – the Black Country is nothing if not hilly – were a latticework of redbrick, green fields, hedgerows, and the colourful steel of industrial units. Kids were playing outside, the kind of thing people, including me, say doesn't happen any more. My psychogeography-senses kicking in, I photographed a suburban redbrick wall with some sections of rough stone slabs set into it, topped off with a tiny section of fence, no more than a foot of black railing with gold fleur-de-lys finials – miniaturised heritage. The tiny reverse-portcullis and panel of stone-like badges said 'this English home is indeed a castle'.

As the sun set, I walked towards Brierley Hill, one of the Black Country towns within the conurbation. This route paralleled and, in parts, coincided with one I made around 1990 when I hiked from Stourbridge to Jennie's house, my first visit there and our second date, which as I recall involved seeing *Gremlins 2* in the Merry Hill Centre, a shopping mall in Dudley developed in the 1980s. One of those moments from which much else flows, rivers of event cascading down the years. Seeing the street again I was struck by how beautiful this place was; the way houses of differing design, some almost Gothically ornate, some sturdy and plain, and the occasional chapel, pub or small factory all combined into long terraces broken only with narrow alleys; the mature trees pushing up the blue bricks around their roots.

Halloween decorations glistened on some of the windows, and there were spices on the evening breeze from the takeaways of the High Street. On the way back up the hill, I glimpsed a strange sight, like a re-enactment of some Homeric mythological incident: three sad-faced young women in the doorway of a house, all in identical dressing gowns, undertaking a rapid transaction with a man in a hi vis jacket.

From Brierley Hill, I walked down to Merry Hill along new roads, much around me still being built. I found the Copthorne Hotel, my berth for the night – a large warm corporate space. Judging by the sign on a 'Coffee/Tea Station', the Copthorne was currently hosting the West Bromwich Building Society for some kind of event. Having dumped my bag, I went for a stroll along the Waterfront, a canalside leisure and dining place near the hotel. Back in the '90s, I was fascinated by the Brewer's Wharf when it appeared on the Waterfront, a pub new-built from old bricks – a novelty at the time. This kind of salvage-themed hyper-reality is common now of course. The Chester hotel-adjunct-pub I had visited had been another example of a widespread trend, whilst back in Ormskirk there are new houses built out of reclaimed brick to resemble converted barns. I had a fancy to finally visit the Brewer's Wharf, but peering into the window at the chilly-looking chrome beer pumps I wasn't drawn. A nearby Wetherspoon's formed part of the Waterfront development, so I went there instead.

Outside again, I explored the rest of the Waterfront. Clearly designed to attract a night crowd, it was mainly empty at this hour. Somewhere called PJs had a banner advertising 'All you can drink for £15' with the web address 'drinkaware.co.uk' in the corner, an incongruous and forlorn hint at 'responsible drinking'. Back in my room, the sound of many people shouting/laughing and exerting themselves to endlessly beating music came

from beneath a large, grey, hoodlike roof outside my window; perhaps this was the Building Society crew, indulging in one last bacchanal before the recession kicked in in earnest.

The next morning, a Saturday, I left the hotel for a £3.29 breakfast from the nearby Sainsbury's, then came back and wrote a blog post in the foyer, sitting on a tiny sofa thoughtfully provided for such random activities. Across the gleaming marble floor at the reception desk people were complaining about the disco noise as they checked out. A brochure invited me to celebrate "A Bejewelled Christmas and New Year", some hard and cold edifice of pleasure.

I wandered about the Merry Hill Centre for a bit, feeling incongruous in my hiking gear; despite the cold day, some customers were wearing shorts. The Centre is an impressive place, one of the largest shopping malls in Europe, the West Midlands' 'shopping Mecca'. It is a late-80s-vintage example of privately-funded regeneration; "an attractive modern retail space built on the site of an old steelworks" was its myth, with the fact that it was also built on farmland kept more quiet. It now claimed environmental credentials, an amiable monster trying to redeem itself. There used to be a monorail here, but due to various legal, technical and economic issues it had operated only rarely. Bizarrely, the monorail was now in Australia.

As Jennie and I did some of our courting here on various cinema trips and pizza meals, this was a place of friendly ghosts, even on a raw cold day when the marble edges of the mall's perimeter shell seem brutally carved into a bright grey sky.

I found it difficult to navigate away from Merry Hill; the endless looping roads and multiple McDonalds, Pizza Huts and KFCs confused me. I figured that Netherton (the next place I wanted to pass through en route to Brighton) was in the east and, as it was still morning, headed towards the bright spot in the sky. Luckily I started seeing road signs before needing to check which side the moss was growing on the corporate saplings. A few minutes later I was in the quiet green depths of Saltwells Nature Reserve, protected woodlands on the site of mining activity traceable back to the 1300s.

Passing through woods and wetlands, observed by white cattle, I hiked up a scrubby gorse-covered hill towards Netherton church. From there, still in the nature reserve, I headed downhill towards Netherton itself. Shortly I was in an overgrown valley, excited to actually be in a wild area I had often glimpsed from the car, from where it looked inaccessible and somewhat magical. This was the sort of place where time might pass at a

different pace, or where a feral child could be raised to become a great hero. Head full of Tarzanic origin myths, I regained the road and strode on towards the town.

I had a drink in the Old Swan, a pub with a dual name, being also known as Ma Pardoe's. A conversation between a man and his elderly mother was depressing me somewhat. She could hear little and, annoyed by her struggle to understand, was irritated and tearful. I left the pub and carried on down the high street, past halloween displays in the windows of a bakery and a hardware shop.

From Netherton my route took me into Old Hill, erstwhile home of Jennie's parents and somewhere I once lived for six weeks, which made it a target waypoint for the walk, in which I aimed to join up everywhere I had lived in a ground-based constellation. That house has been demolished for a while, and I expected to see a weed-grown, fenced-off tract where it once stood. However new homes were already being built on the site and looked nearly finished. It was poignant, thinking of lives lived in spaces that no longer exist, and new spaces waiting to be occupied.

Moving on, I joined the Monarch's Way, a (sporadically) waymarked path which could take me all the way to Shoreham on the South coast if I stuck with it. I walked some canal, some hillside, some densely wooded paths, always with a warehouse or manufactory in sight. Eventually I got beyond the navigable parts of the canal, reflecting that it would probably be possible to walk most of the length of England on waterways if defunct canals were included as well as live ones, and perhaps planned-but-never-built ones too. For instance, I know that there is a dead canal near Chichester, relic of a scheme that could have made a major South coast port, connected directly to London. I was sure that I could make them all join up...

At one point I found myself, having slavishly followed the map, hacking through an overgrown embankment while looking enviously at a perfectly good path on the other side of the canal. Eventually I gave up and walked across, my boots sinking just an inch or so into matted reeds, the canal at this point so silted up that a desire path crossed the waterway. Soon I was on the A458 by the Sandvic works (or Sandtic as my mobile phone's predictive text would have it) – a large landmark factory, locally famous for the enormous Christmas tree it put up each year. This was no big deal these days but, according to Jennie, had been a wonder in the '50s and '60s. I was now in countryside, passing the remains of a monastery – St. Mary's, Premonstratensian Order; presumably once owners of much

surrounding land, under an economic system now dissolved. Light beginning to fade, I trudged on across fields, some stubbled, some newly planted.

I had wanted for some time to arrive at a motorway service station as a pedestrian. The idea of sneaking on foot into a place so obviously designed for cars and drivers had a transgressive feel to it, some abstract form of deviance. In practice this proved difficult. Roads that I had imagined would be walkable had no margin where a pedestrian could avoid cars speeding around corners. I was still nervous in the aftermath of finding myself exposed to fast-moving traffic on a blind corner with no footpath, back in Staffordshire. To bypass the roads, I followed muddy footpaths which eventually took me underneath the M5. From there I trudged through the pathless margin of a ploughed field, climbed a fence and, like the Prince seeking to awake Beauty, forced my way through brambles, finally tumbling to earth behind the garage at Frankley Services on the M5 (Southbound). Dishevelled, scratched and dirty I checked into a Travelodge, which seemed Soviet-austere after the previous night's Copthorne hotel.

I settled down as well as I could in a place made only for transit. The cheap room smelled of seawater, as if an uncanny high tide had risen to this point in the 'heart of England'. I had a picnic of M&S food, eaten with a teaspoon from the room as I had forgotten to pick up complimentary plastic cutlery. After a while I read the literature I had lugged for miles: *The Rings of Saturn* by W.G. Sebald and a stack of Grant Morrison *Final Crisis* comics. Sebald (or his narrator) walks East Anglia and sees "the remains of our own civilisation after its extinction in some future catastrophe", his book illustrated with black and white photos of bleak and pallid landscapes. *Final Crisis* takes the colourful pop culture world of superhero comics, shared intensely by its creators and readers since our collective childhood, into gloomy catastrophe: "Humankind's descent into the Forever Pit has begun! ...entire multiverse – avalanching into oblivion...".

I lay down in the motel, curiously content even though I had spent the day travelling through entropy and decay: my in-laws' erased house, the fading hearing of the old lady in the pub, the canal choked with dead growth. Despite these gloomy things I had found my way through the darkening fields to get here. I had acted as a living entity moving through space. I had seen sadness but was optimistic that the Multiverse would rise again.

Landscape Feature

The mythogeographical 'benchmark' equates the science-based concept of the 'birth of the universe' (an event monitored by space telescopes, analysed by scientists) with the poetic symbol of the Awen, holy source of creative inspiration (written of by mediaeval bards, codified by Druids). In this chapter I am a figure moving through a mixed-up landscape, an admixture of territory that was the way things had ended up on that day, falling into place having followed unimaginable trajectories from the birth-moment. Particles from distant stars drifting down to make the Black Country. The texts from Sebald and Morrison mirroring the origin of things with visions of their ending. Walking backwards through my personal history, trying to channel poetic inspiration before the music from the stars becomes inaudible; seeing and making to counter the trends of entropy.

Walker's Role

Flow

So here we are, hurtling forward in time from the origin that both scientists and poets have interpreted as a kind of music. 'Awen' can be read as 'flowing spirit': let's take this as the energy that flows through the walker from an overflowing, ever-renewing source and walk in, of and as Flow.

Jump Over the Back Fence

Any walk can participate in Flow, and there are no instructions necessary, except perhaps the inscription from Charles Bukowski's gravestone: "DON'T TRY".

Nine: Destination: Argleton!

Legend

Wormhole – a portal to another place, near or far.

– *Mythogeography* (2010, 12)

2009

Google Maps showed an imaginary place near to where I live: a town with the ugly name of Argleton. Mike Nolan, my colleague at Edge Hill, had brought this to light, sharing theories that Google had simply got the name of nearby Aughton wrong (though Aughton appears as well), or that it was a deliberate mistake, designed to catch out unauthorised users of the maps, like a 'trap street' inserted in an A-Z publication (see, for instance, 'Trap Streets Are Real, And Here Are Some Of London's' [Holdsworth, 2015]). However, Argleton did more than just sit there as a hidden feature: it shoved its way into people's attention in many ways. Various software packages use Google's geographical information, and Argleton had primary claim on the surrounding postcodes – so that one could rent property there, or read inspection reports for its nurseries, at least according to the internet.

The possibility of actually visiting an imaginary place seemed irresistible. As a walker interested in the less visible aspects of the landscape, not to go there would be a dereliction of duty, like saying, "I could have made a detour to Rock Candy Mountain but I decided to press on directly to Maghull instead". So one day I decided to make the expedition from the world we know to a fictitious and uncertain place.

Reaching non-existent lands can be accomplished in many ways, but I opted to use Google itself to navigate to this one. After all, they had created the place. I summoned up a route, which turned out to be a straightforward hike along the A59, rather than, say, a trip through the back of a wardrobe. Mundane as this may seem, I kept my eyes peeled for signs and portents, not knowing what relevance a strange map created from a faded planning notice, a stencil with the letters VWXYZ lying on the forecourt of a closed-down garage, some broken fencing in the shape of a hexagram, or a scrap of

poster showing a 'www' blazing in flames might have in later stages of the journey. It pays to be prepared.

If Argleton were to feature in *The Dictionary of Imaginary Places*, it would have good company in the A section, such as Amazonia, Averoigne and Atlantis. Specifically, it would nestle between Argia (which 'has earth instead of air' and where 'the streets are completely filled with dirt... over the roofs of houses hang layers of rocky terrain like skies with clouds') and Argyanna ('a strategically important town in southern Rerek').

What I found aesthetically offensive about Argleton is that it sounded like a mockery of Aughton. Perhaps it was like the Hellmouth in Buffy the Vampire Slayer's Sunnydale, except rather than being a portal for evil beings, it acted as the doorway for forces of debasement, parody, travesty and corruption; forces of error that subtly undermine and distort...

So I approached cautiously, peering towards it across innocent seeming fields, finding the 'place' to be protected by various walls, broken fences accidentally forming the shapes of wards and charms.

I moved towards the epicentre. I paused before passing beyond the realm of true names to that of the unashamedly fictional.

You have to take care at these times. It is all about detail... I had come equipped with apparatus to protect me from any strangeness that might occur. I didn't want to come out the other side reduced to a parody of myself, shambling out transformed into, say, Ray Byfield, Marketing Director of Argleton University. So I had these items with me:

- ❖ A Wonder Woman comic. I thought the Lasso of Truth, wielded by a character created by one of the inventors of the lie-detector, would provide some symbolic defence against irreality.

- ❖ A bad copy of something else: Gardner Fox's *Kyrik: Warlock Warrior* is a pastiche of Conan the Barbarian, a piece of entertaining but unoriginal hackwork; Kyrik is to Conan as Argleton is to Aughton. I thought a bit of this would be a kind of inoculation, passages like "The outlaws stared at that darkness, saw it shot through with streaks of vivid lightnings, red as the fires of Haderon" acting as antigens against any reality-dissolving effects that might be encountered.

- ❖ A toy tapir, bought recently at Transreal Fiction, an SF bookshop in Edinburgh. I figured this little guy must be steeped in alternate worlds: having lived in a science fiction shop for a while, s/he could help navigate back to the real world if some compromised reality became confusing.

The time had come to walk into Argleton itself. A small copse of trees, with a stream and a tumbledown kissing gate, seemed appropriately fairylandish. I paused to photograph the sky, a dim gesture towards Google's satellites – watching, distorting, from above the bright skies.

I was there, on the point of the inverted digital teardrop of the Googlemap pin – then by walking a few more metres I was back in reality: the village of Aughton itself, described in Arthur Mee's 1936 book *Lancashire* as "A Patchwork of the Centuries". This description could lead a fancifully-minded person to expect some collage of time, with biplanes and pterodactyls flying above people hovering to the post office on their anti-gravity discs. However, Mee was really just talking about the church, which unfortunately was locked. But, like Kyrik, I had "Enough [coins] for a wineskin and a leathern jack or two of ale", so I visited the Stanley Arms.

Then I began to think, had I actually left Argleton? Or was I still in some kind of alternate universe? The differences could be minor. Perhaps, in one of the decorative books arranged in an alcove in the pub, one word would be different. Or maybe when I left and peered back towards Liverpool, I would see Lutyens's vast, never-built Metropolitan Cathedral dominating the skyline, instead of the familiar wigwam-form of the actual building.

And I was right to be concerned. As I left, I found the evidence: a discarded, new Woodbine cigarette packet in a hedgerow. I was convinced that Woodbines didn't exist anymore, or rather that they hadn't when I left home. A pack with the modern SMOKING KILLS notice on it was anachronistic, like a horse-drawn carriage with a CD player. But in this world, people still bought and smoked them. So here we were, through the looking glass. Argleton, and all unexisting places, had become a tiny bit more real.

Walking the territory redraws the map.

Landscape Feature

In a field next to Aughton I found a portal to Argleton, 'another place', in this case an alternative version of the real world. My blog post about this sidetrip got a much larger audience than the normal ones, and eventually came to the attention of the local paper. This resulted in a story about 'The Bermuda Triangle of West Lancashire', illustrated with a photo of me looking quizzically at a map. I assumed that would be the end of it, but a few months later a journalist from *The Daily Telegraph*, who had stumbled across the online version of the local piece, telephoned me for an interview. Her piece appeared, both print and online, which led to further coverage; *The Daily Telegraph* is widely syndicated, and the story was swiftly adapted for use by other online sites and publications. Such is the persistent power of media brands. The idea of a mysterious non-place, combined with the mildly interesting issue of the accuracy of mapping data used daily by many people, made Argleton into a popular viral idea. In a crazy flurry of activity, Mike Nolan and I were interviewed separately by TV, radio and newspapers. Argleton stuff proliferated online, with merchandise sites, spoof tourism websites, a crowdfunded novella (Charman-Anderson, 2010), a Facebook page and a Wikipedia entry appearing rapidly. The local pub brewed an Argleton Beer.

The following year, Mike Nolan and I appeared in a BBC Radio 4 show called 'Punt PI', which involved comedian Steve Punt meeting us in the epicentre of Argleton. The producer was keen for me to reprise much of the blog post, even bringing the toy tapir along, and I feared being portrayed as a foil-hatted eccentric. However, the show was well-researched, including interviews with academic cartographers and the data company who supply Google with mapping information. My enduring legacy to the airwaves included the deadpan phrase "the world is stranger than it seems".

Walker's Role

Crosser of Thresholds

Walk as the Crosser of Thresholds, seeking out portals that give direct access to other places and entering them. Portals are everywhere, if you look. Businesses named after a now-past futuristic millennium (Blinds 2000), a Caribbean café in Lytham St. Annes, a nexus of Sussex streets on the coast of the Irish Sea, a digitally-printed vinyl forest filling the windows of a closed-down shop...

You might find portals on any walk. But if you are impatient, a technique to find them (guaranteeing access to other dimensions) may be useful...

Jump Over the Back Fence

Choose a map. Any type of map or definition of 'map' will do. Decide that, for now, the map IS the territory. Scan the map/territory for outliers, anachronisms (things in the wrong time), anatropisms (things in the wrong place), anachorisms (geographical impossibilities), cartographic errors, paper towns, trap streets, any anomalies that indicate the presence of another place. After some diligent scrying (which might take a while: think of Zen monks pondering kōans) one of these places or conjunctions will announce itself: a portal. Walk there. Do the walking, without preconceptions. Notice things. If practical, enter the portal.

NB: If you find yourself lost in the other place you have walked to, do not be alarmed. Assuming you don't have your ruby slippers or a toy tapir to hand, there is a reliable formula to use to arrive at where you really are. Recite the tetralemma:

> The map is the territory, the territory is the map.
>
> The map is not the territory, the territory is not the map.
>
> No map. No territory.
>
> The map is the map. The territory is the territory.

with full belief in every statement. After doing this you will find yourself as solidly and completely located in normal reality as you ever were.

Ten: 'A local habitation'

Legend

Z worlds – microworlds, a galaxy in a beach hut.
 – *Mythogeography* (2010, 12)

2009

I walked from Banbury in Oxfordshire to Brackley in Northamptonshire, starting out along a canal, walking in rising heat, the path lined with huge, prehistorically-leaved and spiny gunnera plants. After a while I reached the M40, where I found a small door to some kind of inspection tunnel, a cool and secret space within the motorway itself. Entering into it via the broken door felt like accessing the narrow night stair of a vast monastery.

I was gleefully excited by this opportunity to creep inside the motorway we have driven countless times, that I had crossed thrice already on various walks, and that (as I knew from reading Joe Moran's book *On Roads*) was the site of an early memory of Lady Penelope buzzing beneath a flyover in a Tiger Moth in an episode of 'Thunderbirds'. It was a moment of entry into the physical stuff of the narrative I was living in. It was exciting but there was no incentive to linger.

I travelled on through the rising heat, until I reached Kings Sutton, a village of almost uncanny attractiveness. A wedding was happening in the church, and I watched the bride arriving in a horse-drawn open carriage as I settled in the pub with a pint of Brakspears. Regional tourism marketeers were keen to claim this place as part of a 'Flora Thompson Country', a kind of dream enclosure within which resonances of her *Lark Rise to Candleford* trilogy were notionally available to visitors.

Once, I had bought a copy of *Lark Rise to Candleford* as a Christmas present for my mum, a fancy clothbound edition which I would find years later, dusty and faded among a small ziggurat of books I had given over the years; mum liked the television adaptations and we watched a Christmas special episode once, white foam sprayed on lush summer foliage in outdoor scenes to give the illusion of winter. But I had never read the book myself, though I did have *a* book with me: a Western novel called *The Tarnished*

Star by Jack Martin. The author's real name was Gary Dobbs and, as well as being an author, Gary worked as an actor on the television show, a sentimental series based on Thompson's book, his Facebook status suggesting that he could be on the set at that moment; his novel skillfully hard-edged, lean writing summoning the fantasy world of the traditional Western, a world shared and co-created by its readers, a genre animated by economic enclosure strategies played out in the West, frontiers advancing and hard men fighting for freedoms already lost.

I walked on, through fields and woods, skirting a playing field with a cricket match in progress, and an airfield launching gliders. I began to feel I was in an imaginary England – even creating one much like the 'Lark Rise' actors.

The sense of unreality remained as, an hour or so later, I walked into a village called Hinton-in-the-Hedges. Crossing the churchyard I could hear music and see glimpses of bright costumes. Assuming some kind of fete was going on, I wandered over, climbing a small stile in a stone wall to enter the churchyard. I realised I was heading towards the backstage area of a play, where costumed children gave me questioning looks. Not wanting to blunder on to a stage or through a dressing room, I started to slink quietly away, but two women holding scripts brought me back and said I could stay and see the end of their performance of *A Midsummer Night's Dream*.

I skirted the edge of the audience and watched the song, dance and speeches that concluded the play, a tall elderly Oberon in a flowing green robe, children with flowers in their hair, Puck releasing the audience from the 'visions' conjured by the performance:

> If we shadows have offended,
> Think but this, and all is mended,
> That you have but slumber'd here
> While these visions did appear.

I joined in the applause and walked towards the church, where I found a beer tent. With a pint of Hook Norton Bitter, I sat on a swing and watched the aftermath of the show, soaking up the atmosphere of people celebrating something that had gone well. I chatted to one of the locals, who told me that the play was an annual event, the performers all from the village, ranging from the youngest to the oldest resident, a span of 70 years.

I felt drawn to the place, as if I could drift into 'slumber', wake and start a new life here, in a village whose name suggested hiddenness – the lines of the 'hedges' on the OS map in a dense pattern resembling the curved translucent chambers of a fly's wing, a strange delicate beauty revealed from above.

Landscape Feature

I stumbled into various self-contained physical worlds on that midsummer day: a community, a village, a performance space, a churchyard. Overlaid onto these were a number of mythical worlds: ancient Greece, an enchanted "wood outside Athens", a dream within the wood; worlds within worlds, each larger than its container. These came together as a *micro*world – a larger thing, the Dream, existing in a smaller space. In the play, Theseus sees this as the fanciful work of "The lunatic, the lover and the poet" who "Are of imagination all compact" ...

> The poet's eye, in fine frenzy rolling,
> Doth glance from heaven to earth, from earth to heaven;
> And as imagination bodies forth
> The forms of things unknown, the poet's pen
> Turns them to shapes and gives to airy nothing
> A local habitation and a name.

But the point is answered by Hippolyta, who can see how the shared, participatory nature of the microworld gives it a greater reality:

> But all the story of the night told over,
> And all their minds transfigured so together,
> More witnesseth than fancy's images
> And grows to something of great constancy;
> But, howsoever, strange and admirable.

There are many types of microworlds. We might also see:

> Corporate microworlds: dioramas in store windows, computer games, certain board games such as Monopoly sets based on real places, any entity called 'Something World' or 'World of Something', locations such as the Loews Portofino Bay Hotel at Universal Orlando in Florida: a trompe l'oeil copy of Portofino Italy, the hotel frontage a facade of multiple pseudo-buildings, real windows alongside painted ones, static Vespas bolted down in a sunstruck plaza – itself part of the larger microworld that is the Universal Studios' Orlando resort, where a variety of media franchise universes are available for temporary immersion in relatively small space – Marvel Superhero Island, The Wizarding World of Harry Potter, 'the mischievous world of The Cat in the Hat'.

Individually-crafted microworlds: such as the Little Italy folly-garden in Corris, Wales – concrete models of Italian buildings, an impossibly crowded model Italy visible from a footpath, perspective giving an uncanny sense of scale.

Accidental microworlds: like a skip containing a pot plant, a door to which assorted Action Transfers had been applied (cowboys, pharaohs and dinosaurs co-existing within one mullioned panel), and an aged sofa surrounded by jagged mountains of plasterboard.

Semi-organic microworlds: like the spaces underneath seaside piers: inhabited by the ghosts of the lovemaking trippers recorded by Mass Observation teams; 'Under the Pier if Wet' Pierrot shows; gangs of Mods sleeping out the heart of a Bank Holiday rampage; the Sandman character played by John Le Mesurier in 'The Punch & Judy Man' film, living a life of unfulfilled promise. "Under the pier, it's a world of the lost and disregarded: partially cooked shrimps and woeful sirens and drowned sailors and horrid cocklers and giant squid" as it says in *Stinkfoot: An English Comic Opera*, written by seaside-pier-town-Southend-born Viv Stanshall with his wife Ki Longfellow.

Walker's Role

Fantastic Voyager

To experience microworlds fully, you need to be prepared to reduce yourself in scale, like the shrinking adventurers in the 'Fantastic Voyage' movie who become small enough to be injected into a human brain. Willing to be a participant in a microworld, existing within it on its own terms, you become (in every sense) a Fantastic Voyager.

Jump Over the Back Fence

Microworlds may be encountered accidentally (you stumble across or into something like "a galaxy in a beach hut"), sought out deliberately (say by seeking out a place which promises a miniaturised version of a larger totality) or brought into being by the walk itself. Any circular walk cuts a small piece of territory out of the world, thus making a unique microworld from your walk. Just remember which side, right or left, is the 'inside' of your walk wherein the microworld is being spawned. Having been cut, it can be pasted somewhere else.

Eleven: Into the Abyss

Legend

 The Liberated Eye – whenever this symbol appears, allow your viewpoint to slip to the landscape around you. If this is not possible close your eyes for a moment and think of what is ahead.

– Mythogeography (2010, 12)

Way back when I started talking to Alan Chapman about becoming a meditation student, he asked if I had ever had any spiritual experiences. Put on the spot, I couldn't think of anything that fitted the bill, but after some thought I remembered being taken to a small park in my pram, close to Rowan Avenue, the first place I remember living; looking up at the clouds and feeling a vast and indescribable sense of meaning.

Eventually, a year or so after my conversation with Alan I reached Rowan Avenue in my walk to Brighton Pier. Looking for the park that was the site of that early memory, I found a small twitten (the Sussex dialect term for an alley, ginnel, snicket, fold or entry) about where I remembered it. I walked down it and found myself in the back of the huge Hove cemetery, a broad and shallow hill studded with headstones beneath a ragged windblown sky. This was quite a shock: could the cemetery have grown so much that it had absorbed my remembered park? It was a logical outcome; many people had died in the last 45 years, and their bodies had to go somewhere. Somewhat cast down by this reminder that 'death had undone so many', I carried on up Rowan Avenue. Soon I found another twitten, which led to a small grassy park with swings and a roundabout, enclosed with back-garden hedges and fences. This was the park I remembered from the pram journey. On this occasion I was not transported by numinous light, but I did see a mosaic with a heart motif, and some graffiti of a heart, broken inside a steaming mug of tea, next to the word GONE written in a liquid looping script.

The meditation practice continued for months and years. It was hard to say what, if anything, was happening, though it seemed that my mind was slightly less reactive and I was generally less caught up in the ongoing struggles of life. In fact, I was often able to step back from the workings of

the mind and just observe thoughts, emotions and the workings of the body coming and going, in what felt like an unbounded empty space. But still, at the heart of it all like a hook in my solar plexus, there was an aching sense of wanting and searching; a desire for the meditation itself to yield some kind of result or satisfaction. I was on a purposeful journey trying to reach a destination. I knew that the idea of a destination was *only* an idea, and nothing to do with whatever awakening, realisation, enlightenment, liberation (or whatever) actually was – but try as I might, I couldn't stop the journey.

Ona Kiser, who had been a pupil of Alan's like myself, had written a book about her experience of awakening, *A Little Death,* which I had read with interest. Her route to realisation seemed more exciting than mine, a rollercoaster ride replete with visions and strange energies. We became friends on Twitter, and when Ona planned to visit the UK we arranged to meet up in London.

The plan was to 'do' some psychogeography and on the train down I tried to come up with something that would fit the bill. Once, while passing through Amersham I had bought a copy of H.V. Morton's 1951 book, *In Search of London.* I had brought this along as a potential reference. The front endpapers comprised an illustrative map of the city. In the bottom corner the map blended into a group of drawings – St. Paul's, Old Temple Bar, the Houses of Parliament. The juxtaposition of the edge of the map and the illustration made it look as if a confluence of roads disappeared into a gigantic pit, Borough High Street, Southwark Bridge Road, Blackfriars and Waterloo Roads falling over a precipice into blank space, actually a sketchily-drawn cloud. Following this outdated map into the abyss became the project of the day.

The accidental pit of the illustration would become for us something more mystical and strange: the spiritual Abyss, the formless space separating the world from its divine source, realm of the Dark Night of the Soul described by St. John of the Cross. From what I had read, the 'dark night' seemed to be an inevitable outcome of the kind of contemplation practices I was doing, a natural stage in which reality is seen as meaningless and all reference points fall away. Perhaps all meditators would end up there. Perhaps all walkers would end up there too, the meanings of the places travelled through collapsing around them...

So, a journey into the Abyss, as a piece of London tourism?

Why not?

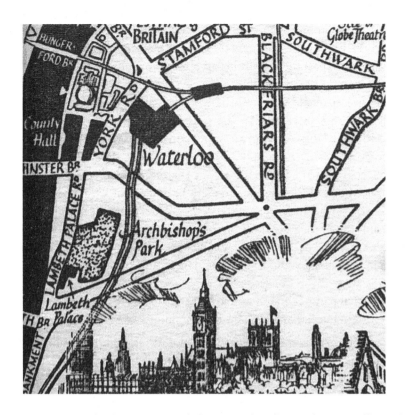

We wandered the hot streets of the capital, talking about stuff on the meditation and enlightenment axis, the fun world of psychogeography and the random stuff of our lives. We crossed the Thames on Waterloo Bridge, where a shouting man in a wheelchair was holding court at the top of the stairs on the northern side, and headed down towards the void. Across the river, London became less capital-like. Rather than recognisably famous buildings there were the dark backwalls of Waterloo. We passed a row of closed-down shops with large digital images of imaginary thriving businesses printed on vinyl and used to fill their windows, to attract future lessees with visions of what could be: thriving hairdressers, bars and restaurants. In non-vinyl reality there was an impressively extensive shop of second-hand office supplies, with chairs and filing cabinets on the pavements. Red-faced drunk people were having an altercation outside a Post Office. We passed through St. George's Circus, where an obelisk stood surrounded by shrubs that had been guerrilla-gardened into place by people wanting something lusher than a barren roundabout. There was a traffic sign showing a road layout as an

inverted pentagram, beneath a university logo comprising an upright pentagram, like an illustration of the esoteric concept 'As above, so below'. We walked on, past the end of the last street shown in the illustration that was our map for the day, and into the abyss.

Later we strolled back towards the river along Westminster Bridge Road, making a brief visit to the Cathedral of St. George where Ona collected some Holy Water in an empty pop bottle. We met up again later, in the Museum Tavern in Great Russell Street. Tina Richardson, a psychogeographer I had met a few times before, came too. We had food – my choice being the large fish and chips branded 'The Codfather'...

Hang on – what happened in the Abyss? Wasn't that the objective of the walk, and therefore a big deal? Shouldn't there be some kind of narrative describing the experience? As it happens, neither myself or Ona can remember anything about it. This could be for one of several reasons:

❖ That part of London was so dull and lacking in features that we just didn't notice anything for the few minutes we were there

❖ We encountered the Dweller in the Abyss, and the ensuing battle was so terrible that it was erased from our minds

❖ There was no Abyss: the veil between the world and its source was merely a concept

...or a combination of some or all of these. Or perhaps, as St. John of the Cross wrote, "Divine things and perfections are known and understood as they are, not when they are being sought after and practiced, but when they have been found and practiced" (2003: 90) – in other words seeking directly to fill an absence of the numinous is not the way to find it.

Months passed back in my normal routine. Then I woke up one morning without the nagging sense of wanting meditation to somehow 'work' that had been an unshakeable accompaniment to meditation for several months. There was no desire for anything at all to be different. I was in, fully in, a fresh moment-by-moment world. Except there wasn't an 'I' or a 'world' or 'moments' as separate entities. Was this enlightenment, 'gone, gone, really gone', through the gateless barrier? No fireworks or sense of achievement or arrival: this was not any kind of experience, spiritual or otherwise, not 'any-thing'. It felt like a profound shift, but not some kind of fancy event, just a clearer seeing of what was and is always there, a baby in a park noticing clouds with eternal astonishment.

Landscape Feature

In parallel practices of meditation and walking I allowed my 'viewpoint to slip to the landscape around' until eventually viewpoint and landscape were experienced as one: a significant liberation. I had set out 'to hack into the reality of the terrain I was walking through', which had sort of happened, in that I had come to see that there was only reality, 'terrain/I/walking' all one juicy item.

This realisation had come, not through acquisition of privileged knowledge or experience of special insights, but through a radically simple process of contemplation. In meditation sits, seeing the mind doing its thing; in walking, experiencing the mind/body as part of the environment it moved through. Paying attention to what is, again and again. I dislike the term 'mindfulness' but it can be a handy shorthand for this perfectly natural human process.

I guess this sounds like 'spiritual' stuff, maybe even 'religious', but there is no requirement to wander off into a fantastical or comforting mysticism. Even celebrity atheist and neuroscientist Sam Harris valorises mindfulness in his book *Waking Up*, as "a mode of cognition that is, above all, undistracted, accepting, and (ultimately) nonconceptual" which "simply demands that we pay close attention to the flow of experience in each moment" and offers "the possibility that one may glimpse something about the nature of consciousness that will liberate you from suffering in the present." Of course, terms like 'flow', 'glimpse' and 'consciousness' are themselves merely analogies, just like the wild poetry of spiritual traditions.

Paying close attention to reality as it appears in each moment-by-moment is fundamental to both meditation practice and mythogeographical walking. The purpose of this book is to submit that these may be useful tools in a deceptive world.

Walker's Role

The Mindful Escapee

By mashing up meditation and walking, I adopted a role of a deliberate seeker of liberation: an escapee.

Walk liberated

> like an escapee

> like leaving jail, it's the jubilee year, all the prisoners are set free
> like shore leave after a long voyage, a two-day pass to a strange new city

> like you never have to be in that house with those jerks ever again

> like Harry Houdini sauntering backstage while the audience watch the shrouded chamber

> like demobilisation from a long war, emerging from the station in a scratchy suit in the town where you grew up

> like being discharged from a hospital, lungs filling with new air

> like leaving the cinema halfway through a film, it was a crappy sequel to an original that may never have existed,

walking into dazzling afternoon light, the buildings both familiar and strange, escaping simply to go.

Jump Over the Back Fence

A liberated walk:

> Set your intention to be completely free for the period of the walk.

> Set your intention to be aware of your surroundings during the walk, by using your liberated eye.

> Walk away from the start point, but avoid any other wayfinding or route-planning.

Whenever you find yourself doing anything other than walking with awareness, 'allow your viewpoint to slip to the landscape around you' and return to the awareness that you are walking in this space.

If this proves difficult, allow the landscape itself to provide reminders: decide that every time you encounter a particular landscape element, it will prompt you to return to simple awareness of walking. Examples might be the colour blue, the number 5, running water, evergreen plants.

(A group, walking in meditative silence, can be a kind of performance. Reverent quiet in an officially sacred space such as a cathedral or grove of trees is pretty normal, but the same silence cut and pasted into a shopping mall may seem marked).

Twelve: Red Nightfall

Legend

Twin Pillars – where god splits.

– Mythogeography (2010, 12)

2015

I had finished a draft of this book after a long day writing. Jennie was away so I fixed myself a one-person meal and started watching TV: 'Daredevil', a superhero show set in the 'Marvel Cinematic Universe', a fictive space containing an expanding series of films and television shows featuring versions of comic-book characters in interconnected adventures. The Captain America movie was, for instance, set in the same world as this TV show. In a kind of adaptation-loop, there were tie-in comics set in the Cinematic Universe rather than the canonical Marvel Universe of the original comics. I loved all of this and had been enjoying 'Daredevil', about a blind lawyer whose senses other than sight are so heightened that he perceives a kind of holographic image of 'the world on fire', but I couldn't settle. After writing about walking all day, I wanted to actually walk somewhere.

It was a spring evening, still light at 7.30, blossom on the trees, the blazing moment when the petals have yet to fall. I strode through Ormskirk, crossing the park where the Edge Hill Vikings, a student American Football team, were practising, past a restaurant where the local Freemasons were emerging from a meeting. On the bridge over the railway tracks, a lion-head drinking fountain spewed only dust. There was a drunk man pulling himself along the wall, moaning occasionally.

I had just missed a Liverpool train but decided to wait half an hour for the next one. A train pulled in, among the passengers a friend from work, linguist Anthony Grant. He joined me on the bench and we chatted in the chilly evening: was there time to go for a quick half? Ormskirk had once had three cinemas; Anthony was about to go to Germany; would I do a reading from this book for the English department? Ormskirk as Viking-named 'Church of the Worm'. Then my train came.

Approaching Liverpool, the docklands buildings were glowing in the sunset: 'world on fire'. Looking down at the bridge over the Kingsway Tunnel (where on an earlier expedition I had seen the graffiti: LIVE WITH PURPOSE/WALK WITHOUT ONE) there was a billboard for the impending Sound City festival; scores of band names including S W A N S who I had seen at the Zap Club in Brighton in 1985, volume loud as an ontological catastrophe in the tunnel venue, its walls endlessly painted black by myself, often compared with Liverpool's Cavern Club due to its arched shape.

Arriving in town I flowed along with the Saturday-night-out crowds, the promissory scents of perfume and cigarette smoke mingling with the street-smells of fast food and diesel.

I walked. Found myself in Rodney Street, seeing for the first time the pyramid-shaped tomb of civil engineer William Mackenzie in the overgrown graveyard of ruined St. Andrew's Church. Then climbed Mount Pleasant, arriving at the Metropolitan Cathedral, the famous 'wigwam' opened in 1967. This was the cathedral I had fantasised to be visible from Argleton in the vast form planned by Lutyens, domed and titanic. I climbed the broad steps, impossible not to think of Rocky films, few people around at this time, some stray balloons bobbing in the twilight. The doors to the cathedral were closed; a laser-printed notice crookedly taped to the wall said this was due to high winds. The 12-foot-square doors and the bell tower above were designed by William Mitchell, sculptor of the disappeared 'Spirit of Brighton', the Egyptian features of Harrods, the 'Corn King and Spring Queen' at the former British Cement and Concrete Association. The doors depict scenes from Revelations: "When the doors slid open, the two halves were meant to stand like sentinels on either side of the Jordan – these were the beasts beating their brazen wings crying 'Hosanna and All Glory to God'" (Mitchell, 2013: 143). One of the beasts "had a face as a man", the deeply-etched features of his winged head (wings "filled with eyes") staring across the city with apocalyptic intensity.

I stood for a while in front of the cathedral, staring out past the Radio City tower at a rose-red, striated sunset. Somewhere in that direction was my home, the suburban tract where I lived in a house with a narrow garden backing onto some fields. Part of the margin of the residential suburbs of all towns everywhere in the West: a row of domestic strip-lynchets many thousands of miles long, abutting agricultural land, commons, parkland, woods; the boundary sometimes marked with a road or path or railway embankment; the scrappy, nettled edge. This was the space where one form

of humanised landscape gave onto another, the territory of entertainment-dormitories ceasing and the tame outside beginning, two natures gazing at each other, like the place where Jack Kerouac slept one "red nightfall" in *The Dharma Bums*, "under a pine in a dense thicket across the road from cute suburban cottages that couldn't see me and wouldn't see me because they were all looking at television anyway".

I would be home soon, but for now I was in the city. The suburban dweller, living in places that are half-nowhere, is always a visitor, on the clock to get home. I descended into Hope Street, which runs the half-mile between Liverpool's two cathedrals. Back amongst people, hurrying on pleasure errands, enjoying the Human Realm. This had been the site of the Market of Optimism, with Ian Smith passing amongst the crowd in his brightly-checked ringmaster's coat. Restaurants and bars were full; Saturday Night was on. I walked past Federation House, which had yet another William Mitchell carving and crossed a street where the tarmac layer seemed to evaporate to reveal cobbles beneath. Kerouac had been to Liverpool in 1943, arriving at the docks as a merchant seaman, about the time Captain America was diving into a New York harbour outside a Liverpool warehouse. On this visit Kerouac "cursed the cobbles because the pubs had closed" (2000), conceived of depicting his times through a lifelong series of novels, sailed home and wrote them. Decades later the books arrived in Portslade Library where I read them as a teenager, scripting myself with beat-generation programming since half-forgotten, to be one of the 'Zen Lunatics' who "go about writing poems that happen to appear in their heads for no reason and also by being kind and also by strange unexpected acts keep giving visions of eternal freedom to everybody and to all living creatures" (1958/2000).

The Anglican cathedral hulked ahead in the evening gloom. I recalled sitting in there looking at the shadows made by a huge undecorated Christmas tree, sensing some kind of numinous depthless space in the darkness, and later entering Liverpool past its gothic flanks at the end of a leg of my walk to Brighton.

I started back towards Central Station to get home. Walking down Leece Street I passed St. Luke's, the roofless 'Bombed-Out Church', hit by an incendiary device in 1941. Maybe parts of it were now in the rubble of the Brick Beach. There were coloured lights inside the nave, as if an event of some kind was happening. Big posters on the doors presumably explained what it was, but I didn't linger to find out. Waiting at the station after my recent walk along Hope Street, I felt rather deflated and lost. On the

platform I was surrounded by fellow passengers, early finishers of nights out, including the residue of a 50th birthday party. My walk had been beset with images, links with the story-so-far of my existence almost absurdly numerous, too many. A multitude of memories, narratives, beliefs, encoded into the architecture or spun out of the aether as I walked along. Ghosts of ghosts, holes through time linking past and present, real and fictional, bedazzling, but also as familiar as the scars and marks on my own body.

The train for Ormskirk arrived and I got on. Two of the 50th-birthday ladies sat opposite me, blearily replaying the night's adventures. One of them removed her shoes. The train started moving and after a couple of minutes emerged from a tunnel. Phone signal popped back to life. I had a look at Facebook. There was a post, from minutes ago, with a picture taken within the Bombed-Out Church. Apparently Liverpool band The Farm were playing an acoustic set in there, right now. The place I had walked past and ignored was full of people I knew! Inside the place I had hurried past were warmth, music, ale, friendship... parts of the network of people I had met, worked with, loved, in this city that wasn't my home. *All Together Now.* Ha!

I could have paid a bit more attention, climbed the steps, read the posters. As always, there had been more to see. I sat back, feeling amused, expansive. I had come to the City looking for signs and symbols, and the Sphinx had served me with riddles made from my own stories-so-far. And when I stopped looking, something new emerged, not just the threads of endless backstories, but a reminder of fresh connections, my friendships in Liverpool where I was a tiny part of a 'momentous octopus' creating unpredictable opportunities for art and fun, spaces where things would happen. This was the landscape feature I had overlooked – *participation.* Just wandering around looking at stuff, a lone flâneur noting atmospheric details, could easily become an ill-tempered, critical and superior form of niche tourism. It was the collaborating part that made it into something more. Not necessarily walking with others, but finding ways to share the experience and insights that came from making walks as play on the boundaries between art and everyday life.

The birthday women were still talking about their night out, with sidelong awareness that I was their audience. I smiled at them; they smiled back; and we enjoyed our shared moment. The train stopped at Sandhills, then continued on its way. My heart beat: systole, diastole; contraction, expansion; emptying, refilling. The ongoing project. Out along the docks tides moved, caressing the shore in a long erotic drift. The burning sky softened and dimmed and it was still early.

Landscape Feature

I found evidence of a split God in Liverpool's twin cathedrals, vast monuments to two traditions facing each other along half-a-mile of Hope Street. The *Mythogeography* book unpacks the Twin Pillars symbol as "two pillars for one deity", symbolising "the splitting of the divine" into male and female manifestations. It is unlikely that the deliberate intent of the cathedral-builders was to encode two theogenders into the architecture of the city, though a secret plan to dominate the skyline of a city with gigantic lingam and yoni to frame a sacred portal is an appealing idea. And the idea can be taken further. If God splits, is it into a mere binary? Maybe the old-school poles of male and female aren't the end of the story – and in the space between plays a boundless constellation of genders, of roles, 'Hope' Street realised.

Walker's Role

Stereo Pilgrim

To walk to and through a place 'where god splits' is a type of pilgrimage. The pilgrim walks in stereo, undertaking a double journey, inner and outer as described by Thomas Merton:

> The geographical pilgrimage is the symbolic acting out an inner journey. The inner journey is the interpolation of the meanings and signs of the outer pilgrimage. One can have one without the other. It is best to have both (in Solnit, 2006: 62-63).

In another doubling, Rebecca Solnit suggests that pilgrimage involves both travelling towards and arriving at such a special site, as

> To travel without arriving would be as incomplete as to have arrived without having travelled. To walk there is to earn it, through laboriousness and through the transformation that comes during a journey (ibid: 50).

Superimposing these formulations, we see pilgrimage is a kind of doubly-doubled activity, inner and outer, journey and arrival. Perhaps the place 'where god splits' is the pilgrim herself.

In order for there to be an arrival, a destination, some kind of special site to travel towards, is required. Spiritual travel-writing often refers to 'thin places', where the membrane between earth and the divine is permeable. There are sacred sites where many have experienced 'thin-ness', such as the island of Iona, "a very thin place where only a tissue paper separates the material from the spiritual realm" (George MacLeod quoted in Power, 2006).

Thin places are also found in secular settings, as in Eric Weiner's (2012) discovery of "a very thin bar, tucked away in the Shinjuku neighborhood of Tokyo":

> Like many such establishments, this one was tiny – with only four seats and about as big as a large bathroom – but it inspired cathedral awe. The polished wood was dark and smooth; the row of single malts were illuminated in such a way that they glowed. Using a chisel, the bartender manifested – there is no other word for it – ice cubes that rose to the level of art. The place was so comfortable in its own skin, so at home with its own nature – its "suchness," the Buddhists would put it – that I couldn't help but feel the same way.

In another kind of doubling, the stumbler into the thin place brings their own mythology to make sense of raw experience – whatever Weiner felt in the Tokyo bar is made sense of with 'cathedral awe' and the Buddhist concept of suchness. However, experiencing a heightened sense of meaning in a particular encounter with a place can happen to any of us, without needing the codification of religious or spiritual traditions or belief systems, perhaps not needing any kind of codification at all.

Is it possible to be a pilgrim without either buying into a massive pre-set belief-system or skipping along as a flighty, inauthentic 'spiritual tourist'? Perhaps. For me, another piece of teenage reading recollected along with the Beats and Kerouac's 'rucksack revolution' offers some clues to a way out of this dichotomy. In *The Journey to the East*, Hermann Hesse writes about a vast and mysterious pilgrimage, undertaken by a mystical 'League'. One characteristic of this journey is that individual participants have their own objectives within the overall endeavour: "Each one of them had his own dream, his wish, his secret heart's desire, and yet they all flowed together in the great stream and all belonged to each other". Their unspecified spiritual path seems radically inclusive: "We visited and honoured all sacred places and monuments, churches and consecrated tombstones which we came across on our way; chapels and altars were adorned with flowers; ruins were

honoured with silent contemplation; the dead were commemorated with music and prayers". The journey itself transcends barriers of time, space and reality: "We moved towards the East, but we also travelled into the Middle Ages and the Golden Age; we roamed through Italy or Switzerland, but at times we also spent the night in the tenth century and dwelt with the patriarchs or the fairies". Participants gain "the freedom to experience everything imaginable simultaneously, to exchange outward and inward easily, to move Time and Space about like scenes in a theatre... we creatively brought the past, the future and the fictitious into the present moment."

Hesse's account is presented as fiction, but points to the possibility of a pilgrimage that overcomes the dualities of inner and outer, walker and landscape, individual and greater whole. Perhaps then, there is a pilgrimage that any of us – theist, nontheist, atheist, panentheist, doubter, seeker, lover, believer – can make.

Jump Over the Back Fence

A pilgrimage for anyone

Decide on a meaningful destination point, theoretically reachable within the time allowed for the walk – but only just.

Define your own meaningful places along the way, equivalent to the "sacred places and monuments, churches and consecrated tombstones... chapels and altars" found in Hesse's story, according to your own preferences. Create a way to honour these as you encounter them.

If in a group, operate like the League, with individual aims (secret or shared) encouraged, and intuitive separation and rejoining allowed for within a loose structure.

Thirteen: Sunken Lands

Legend

Grid – a place of homogenisation.

– Mythogeography (2010, 13)

2009

And one time I was walking up Midsummer Boulevard in Milton Keynes, on a hot midsummer night. MK wasn't on my route, but it made a handy base for a couple of trips, and the idea of staying in a planned new town had a massive appeal. I had often peered at it from the station, finding a forlorn sign for a restaurant (La Hind) attached to the corner of a glass-cliff office block curiously evocative. Aerial photos and maps showed an unnaturally symmetrical road layout of straight lines and right angles. Now I was there, in the straight-line space, sauntering through its spacious arcades. That night I stayed in the Encore Hotel, a new sub-brand of simple-cheap-efficient sleeping machines launched by the Ramada chain. They seemed intent on counterbalancing any alienation which might result from the sparse design and people-lite service with an avalanche of words: signage proclaimed the space to be "exciting, passionate, fresh, stylish, vibrant, upbeat and refreshing".

After checking in at the hotel I went for a drink in a Wetherspoon's pub, this one a new-build in the style of a car showroom with areas of wood panelling making a design-gesture in the direction of traditional inn-atmosphere. On the bar there was a flyer for an art show, 'All Hail Atlantis, vortex of illumination'. This seemed appropriate: I was approaching the sites of long-ago teenage holidays, during which I had read tales of lost lands – Edgar Rice Burroughs' *Tarzan* in Africa, Robert E. Howard's *Kull of Atlantis* and *Conan of Cimmeria*; eternal pulp maps superimposed in my mind on Bucks and Beds.

The next day I left Milton Keynes to walk in Buckinghamshire countryside. The grey wet landscape was cheerless, like Conan's Cimmeria, as the character describes it in *The Phoenix on the Sword*: "A gloomier land

never existed on earth. It is all of hills, heavily wooded... Clouds hang always among those hills; the skies are nearly always gray... There is little mirth in that land" (Howard, 1932/2004: 13).

The fields were lush and wet with rain, so that walking through them gave my legs a cold shower and turned me into a seed-bearer, thousands adhering to my boots and trousers.

A path raised onto a viaduct and some time on roads took me towards the Padbury Brook. Part of the path crossed a field waist-deep in plants – flower-heads poised to open – soon any subsequent hikers would be wading through a pink sea, buzzing with bees.

After some hours I found myself resorting to a disused railway line to make a viable route. Unlike the many disused tracks converted to footpaths that I had walked on, this stretch of the Oxford-Bletchley line still has tracks and sleepers in place, albeit broken and grown through with foxgloves and saplings. Not being an official cycleway or any kind of leisure amenity, pedestrian use was certainly not encouraged as a health and leisure activity; neither was it explicitly forbidden. I followed it for a couple of miles to Winslow, enjoying being in an overgrown hidden world, like a ruined future or a branch line for ghost trains. Some of the saplings were virtually trees and forcing a way through them was difficult. Then the sleepers were underwater, the railway turning into a rill rather than a path. I clambered back to dry land at a small bridge.

On the final bit of road towards Linslade, on a stretch with no walkway, accessible only to cars, I found a half-ruined stone drinking fountain, built for Victoria's Jubilee and restored for Elizabeth's in 1977. A lion's head had once dispensed celebration water, but here, dry in its backwater of time, the lower jaw worn away and long stalactite streaks trailing down from its still-dripping spigot, it seemed to be vomiting limescale.

I limped into Linslade and got the train back to Milton Keynes. There I returned to the Wetherspoon's. The Atlantis flyer had been replaced with one for an Independence Day beer due to go on sale the next day, July 4th. I was never going to see that exhibition, unless I was actually immersed in it already. In Plato's description, the capital of Atlantis, like Milton Keynes, was a planned town, built in concentric rings and served by a massive rectilinear grid of canals. Perhaps this whole place was an Atlantean echo. I got a pint and some food, sat in pleasant physical tiredness, surrounded by people. As Howard had written, giving Conan a bipolar upswing, "Life was good and real and vibrant after all, not the dream of an idiot god".

I went to sleep early in the Encore hotel, but was awoken in the small hours by drunken revelry turning nasty, the sounds of closing-time shouting and barking police dogs rising from seven floors below. Little evidence of the fun-time fighting remained in the empty square the following morning, just a man sweeping up glinting fragments of glass.

Landscape Feature

I followed a fascination with gridded spaces to Milton Keynes, like a barbarian from a pulp adventure wandering into civilisation from wilder spaces. I found the 'grid' appealing, the imposition of straight-lined structure into the landscape somehow bold and offering solace, like a formal piece of music played over the top of a scene of everyday activity, chaos and uncertainty. And yet within the grid, less definitely-structured items appear. In the corporate, portion-control world of a chain pub, a handmade flyer for an art show hints at occult transcendence and a doomed civilisation. Plants grow in the angles. I walk across the lines, sodden, bedraggled, purposeless.

Walker's Role

The Dimension Dropper

The walker comes loping into the grid. The walker comprises a unique combination of looping channels, liquids, fuzzy processes and general indiscipline: a *three-dimensional* body. With the addition of a brain that perceives time and conjures symbols of things that are no longer present ('All Hail Atlantis') the walker could even be described as four-dimensional.

By contrast, the defining structure of the grid is its underlying *two-dimensional* plan. Lines and right angles have been mapped out to provide an efficient logic for structures and functions.

So to enter the grid the walker *drops a dimension*, like the three-dimensional "stranger from Spaceland" entering the two-dimensional "Flatland" in Edwin Abbott's 1884 book of that name. Being within a grid, any grid, is a form of reductive tourism.

Jump Over the Back Fence

Find a grid, for instance by scanning maps for unusually straight-lined spaces.

Walk there, noticing the moment when you cross from normal space into grid-space.

Observe the logic of the grid, discerning the purpose of streets and paths in each direction.

Observe anything which subverts or breaks the logic of the grid, such as

❖ biological growth

❖ broken lines

❖ flowing liquid

❖ residues of older forms, such as ghost streets that cut across the grid

❖ a counter-grid designed to a different logic

❖ juxtapositions of different kinds of spaces (a forest in a shop window, abandoned mannequins making a zombie movie scene in a closed-down café, pop-up social territories created by groups of street drinkers)

Make counter-grid trajectories to open up new spaces. Follow the desire paths. Relish the erotic rush of grid-lift.

Fourteen: Terminalia

1961-2012

I had walked. And everything changed. As a small child toddling around in the first back garden I remember, I looked through the fence onto the playground of an infants' school and strange children peered back at me, saying things I did not understand: a first glimpse of 'others'. Then I was at that school, learning to read, one time the class making a picture of St. George and the Dragon with coloured foil from bottles and yoghurts. Then I was walking past it, on my way from a different house to a different school, a 45-minute hike so that I could save the bus money to buy comics. Then I was walking past it again, grey haired, on a long solo pilgrimage; the school had been demolished, replaced with houses, built on a new street called Old School Place. 'We're all history, baby!' And the route from first-remembered house to first school persists in the geography of my dreams.

"It was a good day to start something – fresh blue sky, a rainwashed town, smell of new air", I had written, back in January 2008, when I started out from Southport Pier. I had planned the route of my long homeward journey to start at a pier near my home and to culminate at Brighton Pier, to give the route a certain symmetry. Today, Easter Monday, 2011, was to be the last day and once again the sky was blue. Instead of after-rain freshness there was the scent of another hot day in a run of hot days, still cool but promising scorching long hours.

I put on the boots I had worn for the whole journey, still spattered in Sussex mud. Blessed on my way at the doorstep by both mother and wife, I hiked on past the rowan trees of the Close I was raised on. Since 1969 I have walked this way hundreds, maybe thousands of times: to play with other kids; to get to school, college, work; to visit pubs in Hove to see my friends. Every version of me walks this route.

Now I was walking it again, making notes along the way:

The Old Village High Street. If all identically-named streets are connected in some way, this street links to thousands of others, including some with totally different characters, such as Edinburgh's 'Royal Mile' High Street.

Cracks on curiously-sited tourism display reveal arcane epicentre – some Hove hellmouth perhaps. The Old Village – the big building was a brewery but has been a factory for several decades. I have read that a Canadian soldier brought a Bren gun down from the roof and shot a local man during the war.

Twitten ('alley') between the infants' and junior schools I attended. Where the fence is now used to be railings, where the padlock that holds the world together used to be. This was a giant padlock someone fixed to a rail in about 1973. It fascinated some of us from the school and many of us tried to get it off. No-one did and it was there until last year, sometimes with a tiny weed growing from the lock. On visits home I would always walk down here and give it a rub, for luck or at least connection.

Once again I ran down the slope to Victoria Park, next to Portslade Library where I read my way through the science fiction shelves. Happy days of The Atrocity Exhibition *and* Dead Fingers Talk. *Path beneath the railway, with officially-licensed graffiti. Lighting embedded in the ground, beaming upwards, gives this tunnel a slightly spooky air, applying a Karloffian look to the most harmless individual.*

Following the twitten-route beside the back of Tesco – an ancient right-of-way, still with some flint wall. Apartments with balconies have appeared fairly recently, suggesting some kind of gentrification project. Maybe one of my other selves has breakfast on one of those balconies.

And so I arrived back where I had last left off, Boundary Road, rejoining that version of myself and getting ready for the final walk.

Boundary Road is also called Station Road – one street, two names. As I understand it, as far as Portslade is concerned it is Station Road but from a Hove point of view it is the Boundary. Or it could be the other way round. It was pretty empty on a sunny Bank Holiday morning.

I had known this street as long as I could remember, and had noticed many changes over the decades. In recent years, cafés and eating places had proliferated along with an ethnic mix unknown back in the days of the

Wimpy Bar and Bistro Edward. (Though there was a Russian restaurant for a while in a side street). I had a coffee in Sami Swoi, named after a Polish comedy film; on the menu it translates it as 'All of Us'. Then for old times' sake I walked down one side and up the other, crossing and recrossing 'boundary' and 'station', between the names.

After that it was time to turn towards Brighton and the final stretch of my walk to the end of the pier.

Landscape Feature

Boundary Road/Station Road, the straight-line street running northwards from grid reference 50.829766, -0.208575 is as much a thing as any thing in the world, but as the 'legend' indicates it does not exist 'in itself'. Its names alone are an indication of this state of affairs: it is a road that acts as a *boundary*, also a road to and from a *station* – a point of connection to other places. It is constantly created by people going there, by '*all of us*' – arriving, staying, leaving with our distinct and intertwined missions.

Walker's Role

Strange Relater

Walking and observing patterns, connections, intersections is an act of forming new and sometimes strange relations. This perhaps is the core of the 'mythogeography' exercise – playfully refusing to take things at face value, seeing what's actually there – "twisting the straight line". Doing the twist to the sound of the earth's long curve...

Jump Over the Back Fence

Walk a straight line for as long as you can, which may not be very long: this task will always fail, but the ways it falls apart can be beautiful. Your straight line will be cut through with intersections and keep trying to twist away like a playful toddler. You can stick to it with the resolution of Johnny Cash singing 'I Walk the Line' but no matter how close a watch you keep on your heart there will be a diversion.

Fifteen: Along the Promenade

Legend

Dragør Ribbons – "I walked down to the Vinterbadere from my hotel in Dragør. These winter bathing huts are accessed from the beach by a narrow wooden walkway. Evening, cold, a spectral blue sky. Suspended above the water, I approached the bone-grey, wooden buildings: utilitarian, unfussy, but tinged with existential menace, like the derelict pier of Carnival of Souls. Overhead a hundred geese flew in articulated ribbons, coherent and chaotic, reaching out and then recoiling, tentacles touching the unfamiliar, a momentous octopus in the sky – with agency, reach and articulation." (From a letter in the records of the C— P. A., unnamed).

– Mythogeography (2010, 13)

My objective was the surviving Brighton pier, and the way there passed its ruined sister, the West Pier. I have dim memories of being on the West Pier before it closed in 1975, the lesser of the two piers with fewer attractions. I was too young to appreciate its role as the 'sex-battleship' of Patrick Hamilton's Gorse novels (Hamilton [1951] 2007, p. 53). Now it was just a mass of twisted girders, separated from the land, looking like charcoal strokes against the background of the gleaming sea.

Further along the seafront, I walked past the entrance to the Funky Buddha Lounge, a club based in the arches that tunnel under the road and face directly on to the beach. Years before, I had worked here when it was the Zap Club, a venue for 'alternative cabaret, music, dance, food and drink' (Bailey, 2006). These genres were often cross-programmed, so an audience might experience a juggler, a comedian, a performance artist and a band all in one night. I was the cleaner at the Zap for two years, my first full-time job. I also did maintenance, bar work, compering, performance, and publicity, the last a mostly voluntary add-on which I have somehow parlayed into a career in marketing.

The cleaning part was occasionally challenging. I dealt with anything which might emerge from a human body, placed everywhere that such

things don't belong. I swept up tons of broken glass and cigarette ash, leavened with the detritus of the Zap's peculiar programme: it was a rare morning when the rubbish didn't include something like a sequinned jockstrap, 17 dead fish painted fluorescent pink, and a broken euphonium.

Amidst all of this I got to meet lots of great people, such as Kathy Acker, Pete McCarthy, Forced Entertainment, Ivor Cutler, Ken Campbell, Billy Childish, the People Show, Sonic Youth, Marc Almond and dozens more. I got drunk, fell in and out of love, made lifelong friends, repainted the walls, killed rats, ruined a pair of comedian Simon Fanshawe's trousers by leaving a freshly-painted table in a backstage corridor, learned to be vaguely entertaining, improvised woodwork, poured drinks, ate microwaved lasagne and tomato crisps, helped present amazing acts, and cleaned up the next day.

Back in the present, the beaches were packed on this sunny bank holiday. I could see the Palace/Brighton Pier, hovering in the heat shimmer, a strange filigreed sculpture of pleasure-seeking. I could be there in a few minutes – but I wanted to spin the day out a bit, so I veered off into town. At the bottom of West Street I cut through a narrow street next to a bar that used to be the New Regent, a venue for punk music back in 1977-8. Back in the day I had seen several punk and new wave bands there as an underage fan: Penetration, Slaughter and the Dogs, X-Ray Spex. There in the shade for a second I thought about the X-Ray Spex gig, Poly Styrene singing 'Oh Bondage! Up Yours!' at a moment when art was saying 'you don't have to accept what's given, there are no rules, have a go yourself'. The memory was tinged with sadness as I had read that she was ill in a hospice. Early the next morning I saw the news that she had died that day, her last Facebook status: "Slowly slowly trying 2 get better miss my walk along the promenade".

My own promenade was now approaching its objective. There was nothing left to do but walk to the end.

So I went on to the Pier. This being a hot Bank Holiday, it was thronged with people. After long periods of solitary walking, as I reached the end of a long journey, half-stunned by sunshine and memory, I was now flowing with a huge crowd. I walked along past various attractions; skirting the large amusement arcade I was among hundreds of other strollers, people sitting in deckchairs and others leaning on the balustrade looking along the coast.

Behind the wedding-cake seafront were all of the miles back to Southport Pier. I had allowed for the possibility of hollow disappointment – 'is that all

there is?' – but instead I was buoyed up, wired... the pier promised 'AMUSEMENT' and I for one was having some, energised by a million steps.

It could well have been 30 years since I was on this pier. Like some native Brightonians I tend to ignore the full-on tourist side of the town. Most of my previous visits had been when I was a student, playing an arcade game called Ice Cold Beer in a tiny bar at the end. The pier had been chosen as an arbitrary aim for this hike, something easier to explain than an unknown street, together with Southport Pier providing symmetrical start- and end-points for a personal pilgrimage. Well, here I was, at the culmination, being carried along in a river of strangers, surrounded by sideshows, the air fragrant with candyfloss and alcohol.

For a while I looked out to sea, much as I had in Southport when I started all of this. The two moments were joined by a huge journey – torrents of green lanes, spates of pavement, years, miles – all now gently collapsed into a single object, surrounded by sea.

Landscape Feature

So, like the narrator of the Dragør Ribbons fragment, I had been drawn to a pier. At the end of my longest walk I found, if not the Carnival of Souls, a kind of actual carnival: a pleasureground suspended above the water on a metal platform. My walk that day had resurrected memories of carnivalesque moments: punk rock, performance art, the psychogeography of the walk itself, scanning the route to the pier for bizarre signs and symbols, the shop window filled with trolls and the posters for the 50 Foot Woman. It had been a long walk, with the unknowable sea at either end. I had made many friends along the way, become part of an unstructured League of ambulatory explorers, our journeys 'coherent and chaotic, reaching out and then recoiling, tentacles touching the unfamiliar.' My trip was done, but who knew where the 'momentous octopus' would lurch off to next?

Walker's Role

Reacher of the End

The plan had been to walk all the way home. By incrementally moving away from the place I live now I had been travelling into the past, or rather into the space where the past had happened – a mission to rediscover 'home' as in 'points of origin', by stitching together everywhere I had lived with my birthplace. Seeing what kind of 'home' existed in my personal history as it is woven into geography. Seeing what the places in between looked and felt like. An investigation to see if there is a solid place to stand supported by the past; some definite sense of location and belonging. Now I was standing, briefly and miraculously above a green and gleaming sea, ghost-train phantoms invisible out here in the sunshine. I had sought 'home' and not found it, just this weird funfair platform over the waves. And that was fine.

Free now from the journey.

Jump Over the Back Fence

Walk until you reach a definite edge: the end of familiar places, beyond which there is only the unfamiliar. Look at what is in front of you. Part company with the narrator: there is nothing left to say.

Outro: (De)Mythogeography

The truth is, of course, that there is no journey. We are arriving and departing all at the same time.'
 – David Bowie (interview – *One on One*, 2002)

Reflecting on my mythogeographical years, what I've been doing is making *real* walks to, in, and around *nonreal* places. The places I moved through were of course physically, prosaically real, as was the body doing the walking. However, the more I walked, the more I experienced landscapes as being intercut with unreal elements: stuff that isn't there but nevertheless has an effect, rather like the "know of a dog" seen by the maid in the 19th-century Shropshire yard (Burne, 1883). "The shape of a dog when the dog isn't there" excited fear despite, or because of, its not-thereness. Walking down Olive Road towards Portland Road in Hove I salivate at the smell of baking bread, even though the bakery was demolished decades ago: my personal geography includes the memory-myth of the Co-operative Laundry and Bakery, a warm blast of yeasty aroma emerging from the forbidding Art Deco walls, potent enough to affect my present-day, physical saliva glands. Maybe I alone experience this. But maybe hundreds or thousands have cried real tears at the sight of the wine glass smeared with lipstick enshrined in the Harrods store: an effect of a collective geography that includes the myth of the dead princess and her association with the location. So that particular piece of geography includes the 'know of a princess' installed as a genius loci beneath the towering sculpted god-forms of the Egyptian staircase.

I learned to see how unreal elements like these infuse the landscape. In the early days I set out to "hack into the reality of the terrain" and "experience the true nature of the places I walked within", "sneaking backstage in the spectacle of the everyday to glimpse the inner workings" – however walking did not in practice lead to Gnostic revelations of a higher order of existence, or special insights beneath the surface of the everyday. Everything was in plain sight. Sometimes I stumbled into the marvellous (wandering into the backstage of *A Midsummer Night's Dream*), sometimes into the banal (the secret doorway beneath the M40 opening into concrete darkness), sometimes into the abyss

(the 3am hospital ward). The way through was always towards reality itself, simply moving with attention to arrive at what is always already the case.

So I walked, with increasing awareness of deliberately-imposed mythologies; the corporate dreamtime of brands, urban regeneration legends of ruins redeemed, theologies shaping skylines, cities as film sets – vast stories encoded in the everyday landscape. I sought out less obvious irruptions of the non-real, such as the technology-spawned ghost-town Argleton, and experimented with transposing pseudogeographies and parageographies on to the grids and contours of actual places, overlaying the Six Realms on to the East Midlands and finding Titans on the outskirts of Nuneaton in the grey dawn. In ordinary places I explored 'popular, trash, pulp layers' and my own 'autobiographical and non-rational associations' (*Mythogeography*, 2010, p. 116), importing legendary warrior-kings to Milton Keynes via a chance encounter with a flyer proclaiming 'All Hail Atlantis' on the bar of a Wetherspoon's, forging a personal ley-line from Southport Pier to Brighton Pier, reinventing Wendy Craig as the Sphinx in the City. And I mythologised myself (ibid: 114), responding to the disturbing influence of my cardiac problem by conjuring a 'wounded healer'/walker role, physical damage becoming a portal into fresh layers of meaning, through which an imagined self could move 'towards/a complicated city/shuddering rhythmically into being' (Bayfield, 2010, p. 71). Although I treated them with the utmost earnestness, I grew to understand that these myths needed no solid, permanent reality. It is, for instance, perfectly possible that the Nuneaton Titans were just an unusually tall couple with a penchant for weird cosplay, their role as Buddhist Nongods conjured only by our encounter on a bridge over the ringroad. (More fool me if they teleported back to the Asura Realm once they were out of sight).

And my own mythologised identities – psychogeographer, pilgrim, the procession of 'walker's roles' in this book – all temporary performances, created, used and now cheerfully released and "set... in orbit" (ibid: 11). Even the individual watcher, the subjective viewpoint carried around as a discrete entity in a bounded body, was a role that could be dropped.

Real walking to unreal places is a practice of simultaneously mythologising and demythologising. Paradoxically, focusing on unreal aspects reveals the real. Tactics such as playfully using impossible elements in routeplanning, or fixating on marginal meanings and walking *as if* these are defining landmarks, aren't *just* a game to explore and enchant: by destabilising our interactions with place, they create openings for direct and fresh experience. As with all

authentic experiences, these can if desired be shared, adapted, made into art, used to inform our actions in the world.

Actively participating in DIY myth-making develops insights that help unmake all myths: a form of liberation. Walking makes it physical. The biped mission: move, look around and see, and move again.

Try it! And go well.

Appendix One

The Mythogeography Manifesto

(from *Mythogeography*, 2010, pp. 113-116, notes elided.)

1/ mythogeography is an experimental approach to the site of performance (in its very broadest, everyday sense) as a space of multiple layers.

2/ it is also a geography of the body. It means to carry a second head or an appendix organism, in other words to see the world from multiple viewpoints at any one time, to always walk with one's own hybrid as companion.

3/ it is a philosophy of perception, always a mobile one; it is a thinking that allows the thinker to ride the senses, and to use those senses as tentacles actively seeking out information, never as passive receptors of it; perceiving not objects, but differences.

4/ the space of mythogeography is neither bounded nor sliced by time, but is made up of trajectories, routes, lines of journey and cargo. The places of mythogeography are defined by the reach and roundabouts of their commerce, traffic, interactions and solidarities. It aspires to a new, mobile architecture of exchange where strangers are changed into friends.

5/ mythogeography, as way of thinking, is led by its margins. As an exploratory practice it is guided by its periphery.

6/ mythogeography is not one discipline, but a setting of many disciplines in orbit about each other; it is not an accumulation of data, but a description of relations and trajectories.

7/ mythogeography mythologises the mythogeographer. Everyone can play their own part, chose their own role. The mythologised mythogeographer's self is one such selected story. The 'self' is a very successful evolutionary category, a super-meme, but mythogeographers can still play 'Nature' and select their own. Then the mythogeographer's self becomes like a discipline,

to be practised just like any other, and is set – like all other the disciplines of mythogeography – in orbit.

8/ mythogeography arose from an aggressive, critical engagement with the monolithic labelling of certain 'historic' spaces by the heritage industry and by agencies of national and municipal identity-making.

9/ mythogeography's weapons against the monocular are the politics and theatre of the everyday, the atmospheres and fictional town planning of psychogeography, the Fortean procession of 'damned data' and (both analogically and directly) geological, archaeological and historiographical methods. It is self-reflexive in the sense that it regards the mythogeographer, the performer and the activist as being just as much multiplicitous and questionable sites as the landscapes they move in.

10/ mythogeography has not developed in a vacuum, but as part of a growing practice of disruptions and explorations, including those of occult psychogeographers like comic creator Alan Moore, performers and walkers like Lone Twin, ambulatory architect-activists such as those of the Stalker group in Rome, urban explorers like the late Ninjalicious and artists of the everyday like Clare Qualmann, Gail Burton and Serena Korda of walkwalkwalk.

11/ mythogeography uses techniques of collection, trespass and observation, and a mapping that upsets functional journeys. It deploys various means to heighten or change perception. It exercises performativity, embodiment and subversions of official tour guide discourse. It subjects the layers of meaning in any place to a rigorous historiographical (or alternative and appropriate) interrogation, while connecting the diverse layers and exploiting the gaps between them as places of revelation and change. It avoids 'scientific' aloofness, or any kind of collapse into a monocular satire or a capitulation to safe and policed forms of eccentricity.

12/ it practises a 'hermeneutics of fear', it is nervous about the annihilation of human consciousness. It adopts a low level paranoia, beginning with, and then testing out, the over-explanation of things.

13/ it does not discriminate between respectable and non-respectable types of knowledge, but insists on the presence of popular, trash, pulp layers, and the foregrounding of the mythogeographer's autobiographical and non-

rational associations, exposing the ways these different layers are received and, through its penchant for try-too-hard/over-ideological trash culture, reaches for a poetics of the Spectacle.

"what is going on in the lower reaches of society is probably very much more potent and effective than what happens in intellectual circles." (Ekkehard Hieronimus)

14/ it studies dynamic forms (the patterns of patterns).

15/ the mythogeographical 'tool kit' cannot be definitively assembled, is mostly invisible (fanciful, conceptual or microscopic), and banal in its material components.

16/ mytho-geography can be spelt with or without the hyphen, but it is a hyphenated practice.

17/ mythogeography is not a finished model, neither in its theoretical nor its practical forms. It is a general approach which emphasises hybridity, and does not attempt to determine what combination of elements might constitute that hybridity.

18/ mythogeography is an invitation to practise, to share and to connect, but also to take the risk of comparison and to practise implicit and explicit criticism of each other's practices and theories.

Appendix Two

A Random Walk Generation Method

A method of generating 'random' choices to determine which route you take.

Carry a pack of cards and a compass with you.

At each junction, pick a card. Each suit represents a direction, e.g.

Clubs	=	South
Hearts	=	West
Spades	=	East
Diamonds	=	North
Joker	=	Stop and explore where you are, the junction itself, then draw again

Follow the direction indicated by the card as closely as possible, using the compass if necessary. Do the walking, without preconceptions. Notice things. The walk ends when it instinctively feels that it has ended; when you end up in a bizarre directional loop; or when you run out of cards.

By using a deck of cards with some kind of themed images in addition to the suits, extra layers of symbolism can be brought into the walk. Either at the time or later on, scan for coincidence and synchronicities appearing from the interplay of the additional meanings in your chosen cards. For instance, one could use a pack of Waddington Marvel Comics cards. Each suit relates to a particular series, so a walk directed by these cards might contain random traces of Norse mythology (Thor), biological mutation (X-Men), physical transformation and hybridity (Spider-Man) or military-industrial technology (Iron Man). One could go deeper into this particular rabbit hole: each card from 2 to 10 depicts a specific comic-book cover, e.g. 'THE FOUR ...OF SPADES' shows the cover of *The Uncanny X-Men* 157 (Claremont et al., 1982); a striking image of a woman standing tall in a pose of arm-waving dangerous fury, eyes white, surrounded by pure magenta smoke, beheld by a group of

shocked-looking characters. 'IT'S **PHOENIX**! BUT SHE'S **DEAD**!' cries one of the background characters, receiving the reply from the main figure 'SURELY YOU KNOW THAT A PHOENIX DIES...ONLY TO BE **REBORN AGAIN**!' 'Phoenix' stands on a reflective, metallic-looking floor and the whole scene takes place in some sort of technological structure. An overall backdrop of stars suggests this may be a spaceship. So, even with no specific knowledge of the story, the card contains all sorts of visual, textual and conceptual content that may be reflected in one's surroundings (death, rebirth, reflective flooring, stars, the colour magenta...) and therefore be part of the walk. Going further still it would be possible to read the whole comic, in which case one would discover that it is all a ruse – Kitty Pryde pretending to be Phoenix to deceive a powerful enemy – so maybe that junction of the walk was a place to discover disguise and trickery used to thwart evil (as seen in the story) or to sell products (as seen in the use of the cover to sell the comic book, by implying that Phoenix had been 'REBORN AGAIN!')

Tarot cards are deliberately encoded with meanings and can be readily adapted for this practice, again by using the four suits for directions. Instead of a Joker, any of the 22 Major Arcana or 'Trump' cards (these are the additional cards in Tarot decks, running from 0, The Fool, to 21, The World) gives the instruction to explore your current position, as well as a cue for how to interpret it.

Wands	=	South
Cups	=	West
Swords	=	East
Coins	=	North
Trump	=	stop and explore where you are, then draw again.

I tried this out in the multi-level Liverpool ONE shopping and leisure centre. I drew the Death card at the outset, on a bridge beside a row of illuminated white trees, a busker with an amp playing 'Paint it Black', and moved through walkways and shops as directed by the cards, Three of Cups ('Abundance') taking me to a Christmas tree made from a cone-shaped fountain of lights in heart shapes, the Knight of Wands jamming me into a dead end recess formed by a temporary fence around a Christmas market bar.

The busker now playing Jake Bugg's 'Lightning Bolt' ('Everyone I see just walks the walk with gritted teeth'). The strange curved dead end I was in felt comfortable, intimate even – like being squeezed by a tender pincer. The Knight of Wands releasing me from that snug corner, the Four of Swords ('Truce') taking me to a viewpoint overlooking both Liverpool FC and Everton football fan shops... and so on, until in Debenhams I was startled to see a life-size skeleton in a lab coat, echoing the Death card and signalling a neat end to the walk. Walking through Liverpool ONE this way meant I saw the place in new ways. Normally I would head for a specific shop, restaurant or the cinema, or else follow the vectors of marketing, allowing shops to catch my attention. This time the randomised use of junctions took me off the routes desired by the retail designers and marketers, into spaces with no obvious purpose which nevertheless had beauty, eros, pathos and excitement – parts of the whole. Sensitised to the signals coming from the environment, punctuating my awareness by drawing the cards, I noticed odd conjunctions and for that brief time was walking awake and alive to where I was rather, than trudging asleep through the splendid corporate dream.

References

Mythogeography (2010) is the main text referred to and (for the avoidance of doubt) is a real book with a real author, Phil Smith; un-named in the physical book itself, and until now in this book.

Other works by Phil Smith are recommended, in particular *On Walking ...and Stalking Sebald* (Smith, 2014), *Enchanted Things* (Smith, 2014) and *Walking's New Movement* (Smith, 2015).

For an extensive and current view of psychogeography I recommend *Walking Inside Out,* edited by Tina Richardson (Richardson, 2015).

Bibliography

Abbott, E. (1992) *Flatland: A romance of many dimensions*. Dover Publications

Arscott, D. (2009) *Brighton: A very peculiar history (cherished library)*. Book House

BBC (2014) 'Pub chain Wetherspoon posts pre-tax profits of £36m'. http://bit.ly/RoyBay15

Bailey, C. (2006) *Zap: 25 years of cultural innovation*. http://bit.ly/RoyBay01

Barnsley, J. (2013) 'Grounding Theology in Quotidian Experiences of Complex Gender: a Feminist Approach'. PhD, University of Birmingham

Barford, D. (2011) 'Occult experiments in the home'. http://bit.ly/RoyBay05

Bayfield, R. (2010) *Bypass pilgrim*. Lulu

Betegh, G. (2009) 'The Limits of the Soul: Heraclitus B45 DK. Its Text and Interpretation', in Hülsz, E. (ed.) *Nuevos ensayos sobre Heráclito*. Universidad Nacional Autónoma de México, pp. 391-414

Burne, C.S. (1883) *Shropshire folk-lore: A sheaf of gleanings*. http://bit.ly/RoyBay02

Charman-Anderson, S. (2010) *Argleton*. http://bit.ly/RoyBay06

Claremont, C., Cockrum, D., Wiacek, B., Warfield, D. and Chiang, J. (1982) 'Hide "n" Seek', *Uncanny X-Men*, 1(157)

Coverley, M. (2010) *Psychogeography (pocket essential series)*. Pocket Essentials

David Bowie interview – One on One (2002) http://bit.ly/RoyBay03

Dairy Crest group plc annual report 2015 (2015) http://bit.ly/RoyBay14

Davies, J. (2007) *Walking the M62*. Lulu

Debord, G. (1955) *Introduction to a Critique of Urban Geography*. http://bit.ly/RoyBay13

Dick, P.K. (2011) *Valis*. Houghton Mifflin Harcourt

Eckert, W.S. (2010) *Crossovers: A secret chronology of the world*. Black Coat Press

Ewing, S., McGowan, J.M., Speed, C. and Bernie, V.C. (eds.) (2010) *Architecture and field/work*. Taylor & Francis

Fleming, I. (2012) *Thunderball: James Bond 007*. Vintage Classics

Fox, G.F. (1975) *Kyrik: Warlock Warrior*. Leisure Books

Garcia, D. (2015) *451 Museum: The Mnemosyne Revolution*. http://bit.ly/RoyBay07

Green, C. (1994) *Portslade: A pictorial history*. Phillimore & Co

Griffiths, N. (2008) *Real Liverpool*. Seren Books/Poetry Wales Press

Hadot, P. (1998) *Plotinus or the simplicity of vision*. University of Chicago Press

Hamilton, P. (2007) The Gorse trilogy: *The West Pier, Mr Stimpson and Mr Gorse, Unknown Assailant*. Black Spring Press

_____ (1941/2001) *Hangover Square: A story of darkest Earl's Court*. Penguin Classics

Hardwick, M. (1985) *Private life of Dr. Watson*. Littlehampton Book Services (LBS)

Harris, S. (2014) *Waking Up: A guide to spirituality without religion*. Simon & Schuster

Hassel, S. (1957/2007) *Legion of the Damned*. Orion Publishing Group

Hesse, H. (1972) *The Journey to the East*. Panther

Holdsworth, R. (2015) *Trap streets are real, and here are some of London's*. http://bit.ly/RoyBay04

Howard, R.E. (2004) *The Coming of Conan the Cimmerian*. Random House Publishing

Jacobs, W.W. (1906/1995) *The Monkey's Paw*. Worthington Publishing

Kerouac, J. (2000) *Atop an Underwood: Early stories and other writings*. Ed. Paul Marion. Penguin Group

_____ (1958/2000) *The Dharma Bums*. Penguin Classics

Kiser, O. (2012) *A Little Death: A journey to awakening through meditation and Magick*. Heptarchia

Macaulay, R. (1953) *Pleasure of Ruins*. Walker and Sons

Machen, A. (2006) *The Great God Pan and the Hill of Dreams*. Dover Publications

Manguel, A. and Guadalupi, G. (2000) *The Dictionary of Imaginary Places*. Turtleback Books

Martin, J. (2009) *The Tarnished Star*. Robert Hale

McLeod, K. (2002) *Wake Up to Your Life: Discovering the Buddhist path of attention*. HarperCollins Publishers

Mee, A. (1936) *Lancashire*. Hodder and Stoughton

Melville, H. (1849) *Redburn, his first voyage*. http://bit.ly/RoyBay16

Middleton, J. (2004) *Portslade and Hove Memories*. Sutton Publishing

_____ (1997) *Portslade in Old Photographs*. Sutton Publishing

Mitchell, W. (2013) *Self Portrait: The eyes within*. Whittles Publishing

Moran, J. (2009) *On Roads: A hidden history*. Profile Books

Morrison, G. (2014) *Final Crisis*. Turtleback Books

Morton, H.V. (1951) *In Search of London*. Methuen

Muir, J. (2001) *The Wilderness World of John Muir*. Ed. Edwin Way Teale. Houghton Mifflin Harcourt

My Brighton and Hove (2007) http://bit.ly/RoyBay10

Mythogeography: A guide to walking sideways (2010) Triarchy Press

O'Leary, M. (2013) *Sussex Folk Tales*. The History Press

Power, R. (2006) 'A Place of Community: "Celtic" Iona and Institutional Religion', *Folklore*, 117(1), pp. 33-53

Public Sculptures of Sussex: Object Details: The Spirit of Brighton. http://bit.ly/RoyBay08

Richardson, T. (ed.) (2015) *Walking Inside Out: Contemporary British Psychogeography.* Rowman & Littlefield International

Sebald, W.G. (2002) *The Rings of Saturn.* Vintage Classics

Sheppard, R. (2010) *The Given.* Knives, Forks and Spoons Press

Smith, I. (2007) *Punkbrighton | The Bands | Birds With Ears.* http://bit.ly/RoyBay17

Smith, P. (2015) *Walking's New Movement.* Triarchy Press

_____ (2014a) *Enchanted things: Signposts to a new Nomadism.* Triarchy Press

_____ (2014b) *On Walking ...and Stalking Sebald.* Triarchy Press

Solnit, R. (2006) *Wanderlust: A history of walking.* Verso Books

St. John of the Cross and Peers, E.A. (2003) *Dark Night of the Soul.* Dover

Stanshall, V. and Longfellow-Stanshall, K. (2003) *Stinkfoot: An English comic opera.* Sea Urchin Editions

Stitt, A., Johnston, M., McKeown, J. and Freeman, T. (2009) *Everybody Knows This is Nowhere: New Work by André Stitt.* Portadown: MCAC

Stitt, A. (no date) *Everybody Knows This is Nowhere (2008-2009).* http://bit.ly/RoyBay11

Stoker, B. (1897/2012) *Dracula.* Ed. Eleanor Bourg Nicholson. Ignatius Press

Taylor, A. (2007) *Temporary Residence.* Erbacce Press

Yakob, F. (2015) *The Man Who Sold his Face.* http://bit.ly/RoyBay09

Trimingham, A. (2001) *Changing Churchill.* http://bit.ly/RoyBay18

Trungpa, C. (1999) *Transcending Madness.* Ed. Judith L. Lief. Barefoot Books

Weiner, E. (2012) 'Where Heaven and Earth Come Closer' http://bit.ly/RoyBay19

Works to Know by Heart: An imagined museum (2015) http://bit.ly/RoyBay12

Not an Afterword

Cecile Oak

Where do you walk once you have walked like Roy?

What remains to be realised? What paths are desirable?

The body, taken apart and reassembled, would agree to what new disassembling of terrain? Or have held onto what inappropriate assumptions in need of dissolution?

Surely, for a walker who has navigated the Six Realms – even for one who has only read of their navigation – no map exists that could be opened without embarrassment?

And if one could be found, what could the first ambience of that next journey possibly be?

For reasons that are unclear, the manuscript of *Desire Paths* was sent to my office in Calabria not electronically but in a parcel containing other items despatched via the good offices of Triarchy Press. Lost within the University's internal postal system I eventually recovered this parcel after a whispered 'tip off' from one of our institution's wonderful catering staff and reclaimed it from the captain of the Ladies Water Polo team who had found it in her pigeonhole in the Marine Laboratory. She had subsequently been observed wandering the rocks of the Coast of Gods and swimming in spirals around the bay. On handing over the manuscript and some ironic broken tourism trinkets, she explained, curiously shamefaced, that she now fully understood our philosopher Galluppi's assertions about the objective reality of our knowledge, and its knowing both itself and the external causes of itself. She chatted enthusiastically about the mason-like qualities of mind, constructing and arranging from the stone supplied. I am not sure where she found any of that in the manuscript; more likely she came across it while communing with blooms of medusa in the whirlpools of the bay or found it confabulated, like a red onion ice cream, by Tonino in the Curso.

Heartened by this example of a Calabrian psychoswimographer going a zonzo in the Tyrrhenian Sea, I abandoned my rational objections to an afterword and wrote something else. For "after" suggests that the journey of the manuscript has ended in words. Or that it could only be continued by a caesura or the trespassing of an event horizon. Rather, I want to suggest that these word-journeys and journey-words of Roy's never ended or ever end, and, once the secrets of them are intuited by a journey-maker, that such a person will be fully contracted to a producing of space that outlasts, and will outlast, all their individual dissembling and disassembling, resembling and reassembling.

Roy did not realise mythogeography in his walk. He transformed mythogeography in his walk. He sawed it from the hands of its creators and he gave it a different heart. Now, it is time for mythogeography and the mythogeographers to repay the compliment. To step up by stepping back; time for the creators to sit on their hands for a while and allow new striders and pacers to respond to those affordances and lapses that *Desire Paths* peels open, like a knife to fruit.

The manuscript I had the pleasure to read, a little salty after its spiralling trips around the bay, at times put me in mind of the different ecclesiastical architectures here in Calabria; holding out the possibility of an extreme cathedral form for mythogeography, a closer and more ambitious entangling of its small chapels of eccentric specialisation. The constructive suggestion, and it is only a suggestion, that it might now be the right time for the mythogeographically inclined to produce more in the way of totalities than fragments. Movies, novels, space operas, maps the same size as terrains, architectural quarters. For in the complexity of a totality there is a vulnerability to its own contradictions, an accountability that mythogeography might have to court if more people are to take it at its word as Roy has and pursue it as an ethical, personal and social journey. Too many clown politicians (and Italy has been awash with them, recently) have rendered performativity alone inadequate and untrustworthy; what we need now in our globalised post-imperial mess (as well as the candour to admit how little these ideas have reached the people who could really use them) is a walking that is both quest and architecture, everyday and everlasting, leave and remain (a suspension that my compatriots in the UK have so spectacularly failed to achieve), dirty and ideal.

Whatever tricks Roy's mind has played on him, and plays on us, the Abyss is real and we must map its rim. The trauma of colonialism is untreatable; everything we do rests on its loss and silence. Such vacuums, if

understood, are allies against The Spectacle, its invasion of subjectivities by algorithms and its pixilation of public spaces.

Roy and others are taking hyper-sensitisation-to-space about as far as they can. The next stage will be the evolution of new senses and new sense organs. As far as I can see, mythogeography shares very little with Futurism, but neither does it have anything to fear from it. Synaesthesia and trans-sexuality will overwhelm the dérive in the same way that walking's latest movements have been transformed by the activism of women. Such counter-invasions, against The Spectacle, will shift our disguises from those of dérivistes to those of a proto-mob, a crowd again, trespassing en masse.

Desire Paths articulates a duty to mystery, a quest beyond dogma, a tearing up and transcending of the Camino and its diversion from the narrow way by new shrines. And then what? An ecological walking that acknowledges the malevolence of the planet's molten centre? That unbends its own straightening as a result of bipedalism? Will we see the great philosophers of walking – Gros, Nicholson, Self – learn to crawl again? And gravity be re-understood and re-embraced, not as a force but as waves; as the means of a communication through the membrane to the next universe along? And will we see the end of motoring, brought about by single pedestrians standing in the middles of roads unable to explain themselves?

Perhaps a new wizarding in on the way; isn't that the main thrust of *Desire Paths*? Stalling Gnosticism in the ruins of pseudo-sacred spaces, in Poundland/Disneyland and pub chains, in bouncy Stonehenges and theme park heritages, with the suggestion that what has appeared already as farce is coming back as noble and serious tragedy? Giving Hegel an extra flip. That is the trick that Roy has carried off: deploying the absurd and playful tactics of mythogeography and yet making a sense from them. What *Desire Paths* does not say because it is too modest and yet encourages because it is so immersed is that others might take up their own multiplicity and entangling of styles, their own moral accountability to tragic flaw and to the totality of temporary communities acting back to themselves. And then mythogeography would shift from finessing a solo walker's perception of ambience to irreversibly transforming the material atmosphere-production of the everyday for everyone. Psychotrespass. Brain Mobs. Demolitions and redevelopments by asymmetrical means; the détournement of the most abject spaces of entertainment, heritage and pseudo-religion into allegorical one-to-one maps of the 'big picture' of everyday-everywhere. Perhaps the instabilities of Southern Europe, its shores now full of footprints from North Africa and the Middle East, have made me overambitious for the

gentle shift in this manuscript between the deeply personal and affective to the sociable, social and ethical. Colleagues and walkers in the colder parts of the planet will have to forgive me if what comes recommended here has been stroked by the toe-end of Europe and therefore curls a little to get over the wall.

However, I do not think I have entirely imagined in Roy's journey the freeing of the dérive-mind from the chains of flânerie's solipsism; nor a shift away from the culture of lonerism to disappearance in the wisdom of the leaderless congregation of individuals, spread across the tables of a Wetherspoons (not many of those in Calabria, though there are plenty of bars and many congregations of the disparate), and a readiness to run with the unhating mob. I think there is a sewing together of fragments of democracy here, in the patchwork of which 'Luther Blissett' and 'Karen Eliot' (let alone 'Crab Man' and 'Signpost') no longer seem anonymous enough; but, rather that what is obliged is something closer to my feeling, having walked with Roy across so many pages, so much skin, so much land, that I will anti-self, that I will mask up. And that 'They' will not know me, that 'They' will not find me. That I will hide in the crowds, if necessary. I will share the 'Ndrangheta's tunnels.

After all, doesn't mass and variegation stand against homogeneity and hatred, just as much in a hedgerow as in a public square? Just as much in a public square as in a hedgerow? Colonialism, slavery, Holocaust, Armenia, Rwanda, the Tasmans, Ukraine in the 30s, West Bengal and Irish famines, Hiroshima, the Gulag, Native Americans: we forget any abyss at our peril (and this list is one of forgetting). In layers of symbols and things we work our way. There is no identity; all is connected, all is field.

For every atrocity there is a stupidity, the one scaffolding the other: Ice Theory, Cobra Mist, The Duga, Tuskegee Syphilis Experiment, mutually assured destruction, House Un-American Activities Committee, the Nazi-Soviet Non-Aggression Pact, the wicked womb, chemical warfare, the rapture, the NRA, and so on; the follies of neoliberalism and authoritarianism and their entangled cousins. In their ruins we rejoice and from them build an anti-novel new. Taking back the surplus of pleasures taken from us (both in markets and in prison camps); this is the populist heartbeat that mythogeography's founding aunties and uncles have patently failed to smother despite their obscure and trivial games, trials and intellectual ordeals.

Scraping the crystals of salt from the pages of *Desire Paths* has coloured my reading, maybe made it a crude one. But then perhaps mythogeography

should get crude and lose its good name? In labyrinths of fear and illusion, the dérive will have to hammer through the walls; make its own version of gravity waves. Breaking through to other universes; because the revolutionary cry is no longer about the changing of the world, but about an exchange of universes. Dark energy, Higgs boson, gravitational waves; what if we make these the field politics of the anti-Spectacle? Politics as science fiction and energy-lite space travel; the displacement of our selves to somewhere barely there?

The gorgeous generosity of Roy the walker stands out like a beacon of shining blackness, a silhouette of coal against the beam of a searchlight, illuminating the politics of Social-Darwinism under which we are increasingly forced to live; reading Roy, we will want to live instead in sociable quantum fields, where our entanglement with distant things, no matter how unapparent, determines morality here and now. We will want to participate in a revolution of understanding in the production and the living of everyday space. Is that not the thrust of every mythogeographical dérive? And anything less is a dishonouring of our pantheon – Nan Shepherd, Margaret the Duchess of Newcastle, the Peace Pilgrim, Laurie Anderson, the October 5th Women Marchers on Versailles and those Zapatista women who "caminando preguntamos" (ask questions as we walk)? Mystery, mob, wizardry and practical re-making all entangle in a totality in each small thing?

Roy, you don't know what you've started. Or maybe you do. Mythogeography Extreme!

Dr. Cecile Oak
Cavaliere Antonio Zonzo Fellow in Non-Representational Practice
University of Tropea,
Calabria, Italy

About the Author

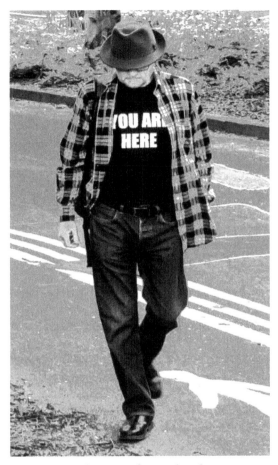

Photo: Jennifer Woodward

Roy Bayfield has appeared in a list of "exemplary ambulatory explorers", is well known for his explorations of the notorious Argleton (a Google Maps un-town), and is one of the small group of contemporary walker-writers who are stepping out beyond the work of W.G. Sebald, Will Self and Iain Sinclair.

His previous publications include a story in the seminal anthology *Britpulp!*, a chapter in the defining work on the new psychogeography, Tina Richardson's *Walking Inside Out*, and a poetry collection, *Bypass Pilgrim*.

Acknowledgements

Big thanks to:

- ❖ inspiring fellow-walkers and encouragers, in particular Duncan Barford, Andrea Capstick, Carl Hunter, Rhiannon Evans, Simon Harvey, Ona Kiser, Tina Richardson, Morag Rose, Robert Sheppard, André Stitt, Robyn Woolston and many more

- ❖ Andrew Carey at Triarchy Press for invaluable guidance that has driven me in the journeys involved in producing this work

- ❖ Jennifer Woodward for early-morning photoshoot

- ❖ Ian Smith for announcing me onto the stage

- ❖ Alan Chapman and the Fountainhead Wisdom Service

- ❖ friends and colleagues at Edge Hill University

- ❖ at the risk of gilding the lily, to Phil Smith/Mytho/Crab Man for assembling and electrifying the Mythogeography monster

- ❖ and finally, for extensive assistance on the text and for an infinite landscape of other things, to Jennie.

Also from Triarchy Press

Ways to Wander – Claire Hind and Clare Qualmann

54 intriguing ideas for different ways to take a walk – for enthusiasts, practitioners, students and academics

Walking's New Movement – Phil Smith

A foot-tour-de-force about developments in walking and walk-performance for enthusiasts, practitioners, students and academics.

A Sardine Street Box of Tricks – Crab Man and Signpost

A guide for anyone making, or learning to make, walk-performances.

Enchanted Things: Signposts to a New Nomadism – Phil Smith

This photo-essay draws our attention to a "chorus of surprises… yelling from the sides of the road like particularly unruly spectators at a parade".

On Walking... and Stalking Sebald – Phil Smith

"a life-changing beautiful book!"
On one level *On Walking...* describes an actual, lumbering walk round Suffolk with its lost villages, Cold War testing sites, black dogs, white deer and alien trails. On another it sets out a kind of walking that the author has been practising for many years and for which he is quietly famous. It's a kind of walking that burrows beneath the guidebook and the map, looks beyond the shopfront and the Tudor facade and feels beneath the blisters and disgruntlement of the everyday.

Mythogeography

The mother.

www.triarchypress.net/walking

Lightning Source UK Ltd.
Milton Keynes UK
UKOW05f2007170217

294712UK00006B/60/P

9 781911 193043